THE DOCTOR WAS
A WOMAN

THE DOCTOR WAS
A WOMAN

Stories of the First Female Physicians on the Frontier

CHRIS ENSS

TWODOT®

Essex, Connecticut
Helena, Montana

A · TWODOT® · BOOK

An imprint of Globe Pequot, the trade division of
The Rowman & Littlefield Publishing Group, Inc.
4501 Forbes Blvd., Ste. 200
Lanham, MD 20706
www.rowman.com

Distributed by NATIONAL BOOK NETWORK

British Library Cataloguing in Publication Information available

Library of Congress Cataloging-in-Publication Data

Names: Enss, Chris, 1961– author.
Title: The doctor was a woman : stories of the first female physicians on the frontier / Chris Enss.
Other titles: Stories of the first female physicians on the frontier
Identifiers: LCCN 2023032063 (print) | LCCN 2023032064 (ebook) | ISBN 9781493062928
 (cloth) | ISBN 9781493062935 (ebook)
Subjects: LCSH: Women physicians—West (U.S.)—Biography. | Physicians—West (U.S.)—
 Biography. | Medicine—West (U.S.)—History.
Classification: LCC R692 .E667 (print) | LCC R692 (ebook) | DDC 610/.922—dc23/
 eng/20230825
LC record available at https://lccn.loc.gov/2023032063
LC ebook record available at https://lccn.loc.gov/2023032064

∞™ The paper used in this publication meets the minimum requirements of American National Standard for Information Sciences—Permanence of Paper for Printed Library Materials, ANSI/ NISO Z39.48-1992.

Contents

ACKNOWLEDGMENTS

If I thanked everyone who helped with this book, my acknowledgments would be longer than the text itself. However, several people deserve special recognition. Dortha Pekar was a delight, and it was a pleasure to spend time talking with her about Dr. Sofie Herzog, Texas, history, and politics. Dr. Juliana Parry, DDS, helped point me in the right direction to find details on Dr. Lucy Hobbs's career. Ashley Thronson, reference specialist at the State Historical Society of North Dakota, aided in pulling together everything needed to write about Dr. Fannie Dunn Quain. Jen Barkdull at the Church History Library in Salt Lake City, Utah, went to great lengths to make sure I had copies of Dr. Pratt's medical papers. Chris S. Ervin, archivist at the Santa Barbara Historical Museum, did the same with Dr. Harriet Belcher's journals.

I'd like to thank Suzi Taylor at the Wyoming State Archives, the Yankton County South Dakota Historical Society, the University of Nevada, Reno, the Arizona Historical Society, and the Denver Public Library.

Lastly, a tip of the old hat to all the scholars whose work I have cited within these pages. The trail to truth is long indeed.

Introduction

The new woman is a physiological as well as a psychological study. She is evolving herself out of her pleasing, comfortable home-life environment into a cold, distrustful, criticizing world in which it is doubted she can accomplish as much good in any direction as if she remained in the sphere, medically speaking, to which she is most suited.

Pacific Medical Journal, 1895

IN THE DAYS WHEN THE FIRST WAGON TRAINS WERE PUSHING THEIR ways beyond the Rockies, pioneers made the trip with limited provisions of food, firearms and ammunitions, tools for building, and medical supplies. Some of the medical supplies included peppermint oil, quinine for malaria, hartshorn for snakebite, citric acid for scurvy, calomel, camphor, and morphine. Among the so-called medical books, the sojourners brought with them *Gunn's Domestic Medicine: Or Poor Man's Friend, Shewing the Diseases of Men, Women, and Children, Expressly Intended for the Benefit of Families. Gunn's Domestic Medicine* was written by John C. Gunn in 1830. Gunn earned a college degree in the field of mercantile mathematics before turning his attention to medicine. He did not go to school to learn about medicine; he simply read books on the subject. Beyond that, he observed physicians at work at practices in New York, Cuba, and England. The tome sojourners traveling to the West relied on to help them with everything from amputations to whooping cough was penned by a man who never himself treated a patient.[1]

If there had been a physician traveling with the parties heading westward, his background in medicine might have been as limited as

Gunn's. Many of the professed doctors weren't professionally trained. The knowledge they acquired came from time spent working alongside physicians who had gone to medical school. Those living in rural areas who had an interest in medicine but couldn't afford or hadn't had access to college relied on practical experience for their education. Settlers tended to trust the physician with practical experience over the academic. They believed their hands-on education made them more equipped. That idea extended to women acting as midwives on the trail too. Diaries and journals of expectant mothers who were part of various wagon trains note the importance of the midwife in assisting with the birth of babies born on the journey and with postpartum care. Midwives, many of whom had given birth to many children of their own, could be trusted to bring life to the new frontier, but women in general were considered too fragile to learn anything beyond rudimentary pediatrics.[2]

Some of the first women to break through such antiquated thinking were from the Mormon faith. Pluralistic marriages were the norm within the religion, and as the number of wives in one household increased, so did the number of children. Church leaders saw the need for physicians in expanding communities and urged women to respond. Mormon women such as Martha Hughes Cannon, Ellis Reynolds Shipp, and Jane Wilkie Manning Skolfield were some of the first ladies to attend medical school in Utah. They were accepted as qualified physicians when they returned from college and opened their practices, but other women who sought and obtained medical degrees struggled in the profession because they were women.[3]

After graduating from the New England Female Medical College in 1855, Massachusetts-born Dr. Martha Nichols Thurston believed she'd have more of an opportunity to practice medicine beyond that of midwifery on the West Coast. Doctors were far and few between in the unsettled land, and Martha reasoned needy patients would turn to her for help. For a time it seemed most trappers, miners, and merchants would rather suffer and die than consult a woman doctor. Eventually, Martha was able to gain the public's trust and was then able to create a thriving practice.[4]

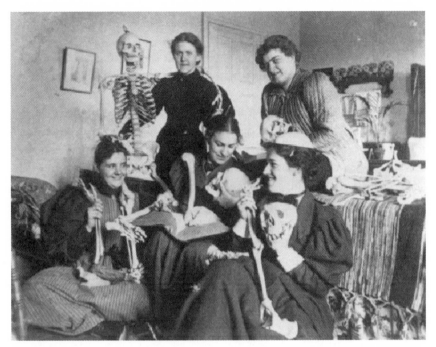

Medical students acting up while studying for an anatomy test in 1892. Courtesy of the College of Medicine, Drexel University (photo in public domain).

The efforts of women like Martha Thurston made it possible for lady physicians such as Dr. Maria M. Dean to gain acceptance more readily in wild frontier locations. Born and raised in Wisconsin, Maria Morrison Dean moved to Helena, Montana, in the late 1880s after graduating from the University of Wisconsin and the Boston University School of Medicine. She became the first woman licensed to practice medicine in the state.[5]

Dr. Dean was known for the concern and attention she gave to women and children struggling with serious infirmities and to those in the community struggling with mental illnesses. By 1900 she was recognized as one of the most successful homeopathic women physicians in the West, and her annual income was between $11,000 and $12,000.[6]

Dr. Helen MacKnight Doyle's father was fiercely opposed to his daughter becoming a doctor. He had difficulty understanding why she would pursue what society deemed at the time as an unladylike profession.

Not only did she go against her father's wishes to attend medical school, but she also went on to fight against the residents of a Nevada mining town who initially would not accept her as a physician. She persevered, developing a lucrative practice that, in her words, "exceed[ed] a doctor's Arabian Nights dreams."[7]

In 1899 Justina Laurena Warren Ford graduated from Hering Medical College in Chicago with a degree in medicine. She established a practice in Alabama shortly thereafter but found the community was hostile toward black women physicians. She headed to Denver, Colorado, where she reasoned she would stand a better chance at attracting patients. Sick and hurting people with low incomes who were routinely turned away from doctors' offices that catered only to the elite eventually sought her services. Justina specialized in obstetrics and pediatrics and either walked or took a horse and buggy to call on patients. She became known as the "best baby doctor" in the city.[8]

Women physicians' love for humanity and zest for pioneering were strong. Where doctors were few in the regions beyond the Mississippi, prejudices against women in the profession weren't as often acute. When they were allowed to prove themselves, women physicians provided vital medical treatment for the chronically ill, repaired broken bones, performed major surgeries, battled pandemics, and built hospitals. They faced and overcame obstacles their male counterparts never had to encounter and, in the process, forged new paths for women in the field of medicine.

What follows are some of their stories.

Jenny Murphy

Yankton Doctor of Medicine

In good weather you'd see her bicycling around town on her calls with her little satchel over her shoulder. In bad weather she'd take her horse and buggy.

<div align="right">

ARGUS LEADER, 1951

</div>

DR. JENNY MURPHY FLIPPED THE COLLAR UP ON THE THICK, GRAY COAT she was wearing and tightened the grip she had on the medical bag in her lap. It was below freezing when she left Yankton, South Dakota, in November 1894, on her way to a homestead in Nebraska, and temperatures continued to plummet. An anxious farmer had burst into her office in the afternoon and pleaded with her to accompany him to his home to help his wife deliver their first child. The man's farm could only be reached by crossing the Missouri River.[1]

Dr. Murphy followed the expectant father to his canoe anchored at the river's edge and climbed inside. The water was cold, and chunks of ice clung to the shoreline. The farmer pushed off from the bank and quickly paddled into the middle of the water. He avoided most of the chunks of ice pulled downstream with the strong current. Just before they reached the other side of the river, a massive hunk of ice slammed into the boat, and it overturned. The doctor and the farmer were dumped into the water.[2]

Still holding on to her medical bag, Dr. Murphy fought her way to the bank of the river and onto dry land. The frazzled farmer also managed

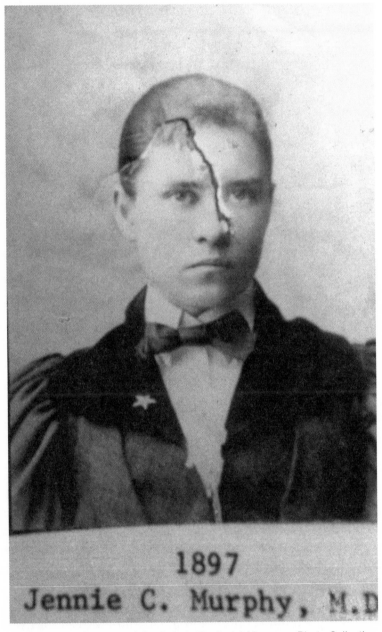

1897

Jennie C. Murphy, M.D

Dr. Jenny Murphy. Courtesy of the Dakota Territorial Museum, Photo Collection, Yankton, South Dakota.

to get out of the water. He gave the doctor a moment to recover from the near-drowning experience before hurrying her along to his homestead. When the pair arrived at the farmhouse, Dr. Murphy's clothes were still wet from the swim in the river. Peeling off her coat and apron, she rushed to the bedside of the farmer's wife just in time to help her deliver a healthy baby.[3]

It is doubtful Jenny Murphy imagined the extreme lengths she would have to go to care for patients when she decided to become a doctor. The path women had to take to achieve a medical degree in the 1880s was difficult. Women were not welcome in the profession. Men so opposed the female presence at medical schools that fighting the idea that women weren't smart enough to be physicians was like swimming upstream in a strong current. The years Jenny struggled to go to school to become a doctor helped prepare her for the grueling but rewarding career.[4]

Jenny C. Murphy was born on February 20, 1865, in Alleghany, Pennsylvania, to Major Hugh and Violet Murphy. Jenny and her family moved to Yankton, South Dakota, in 1878, when she was thirteen years old.[5] In addition to attending school and helping her parents care for her brothers and sister, she also worked as a bookkeeper at a lumber yard. A portion of the funds was used to support her family, with the remainder set aside for school. Jenny knew early on she wanted to go to college, but it wasn't until she took a job in Dr. James Buchannan's office that she realized she wanted to pursue studies in medicine. The time spent at Dr. Buchannan's practice handling his billing exposed her to a myriad of patients with an assortment of ailments, all of which she wanted to learn how to treat.[6]

The cost to attend medical school was exorbitant. Jenny knew she'd have to find a better-paying job to save enough money. She decided teaching school was her best option, and after graduating from high school in 1883, she took the teaching exam. Shortly after passing the test, she applied for a position at Grove School in Yankton County. The education board hired her, and in the fall of 1883, she began the first year of a five-year career as a teacher.[7]

According to records at the Yankton County Historical Society, Jenny was exceptional at her job. She had a firm and organized teaching

style that made her popular with both her students and with school administrators. Within a year of being hired at Grove School, officials at the grammar school in Brookings, South Dakota, persuaded her to work for them.[8]

During her time at the Fishbeck School District, the region was struck by a massive snowstorm. The blizzard occurred on January 12, 1888, and killed more than five hundred people. Many of those who perished were children who were at the school when the fierce blizzard hit. Jenny's class had just come inside from recess when the storm occurred. Gale-force winds shook the schoolhouse, and the rapidly dropping temperature turned the interior of the building into an icebox. Whiteout conditions made it impossible to see anything outside. Jenny gathered her class together by the potbelly stove and covered them with the few coats, blankets, and rugs she could find. She wouldn't allow boys and girls to leave the premises until the danger passed. According to an interview Jenny gave years after the incident, she had the students "create a human chain outside so they could tie a string from the schoolhouse to the woodshed, so they could get wood but not get lost in the storm."[9]

During the evening Jenny kept the children's minds off the harsh conditions outdoors by writing letters, singing, and playing games. At bedtime, when all was quiet and the teacher and students were trying to fall asleep, they heard a faint cry for help in the wind. Jenny and a few of the older pupils stood in the open door of the school calling out to the weak voice, but there was no response. When the storm passed, the frozen body of a man seeking shelter was discovered nearby.[10]

By the end of her term, Jenny had saved enough money to attend college. She applied and was accepted at the Hahnemann Medical School. Located in Chicago, the school opened in 1860 and became coeducational in 1871. The all-male college administrators informed Jenny that if she failed to finish her first term at the top of her class, she would be asked to leave. Jenny was serious about her studies. In addition to working a full-time job to pay for her living expenses, she devoted herself to getting high marks. She did well and was invited back to complete her sophomore year.[11]

The long hours poring over medical books and long hours on the job were exhausting for Jenny. She returned to South Dakota after her sophomore year to spend the break visiting with her family and resting. It wasn't until she'd been home for a few days that she realized she was ill. She was suffering with tuberculosis. Jenny's mother cared for her daughter during the recess, and by fall, when she was scheduled to return to school, her health had been fully restored.[12]

Jenny graduated with honors from college in 1893. Coincidentally, that was the same year as the first World's Fair in Illinois. Included among the exhibits and attractions was a state-of-the-art hospital. Jenny did her internship at the facility. The hospital specialized in helping cardiac children. At the conclusion of the six-month event, Dr. Murphy returned to Yankton to open her own practice. Mindful of the advancements made in the medical profession, she decided to close her office between 1896 and 1898 to travel to New York to gain additional training in women's diseases and children's illnesses.[13]

In 1898 Dr. Murphy joined practices with two other prominent physicians in Yankton. The October 21, 1951, edition of the *Argus Leader* reported that shortly after opening the office she shared with Dr. E. W. Murray, she became "instrumental in the formation of the town's earliest society of medical men and [was] named the organization's secretary." Dr. Murphy helped found the first hospital in the area.[14]

The life of a female country doctor was a rugged one. Jenny's territory radiated some twenty-five miles or more in every direction of Yankton. Enduring rain and snowstorms and traveling over rocky terrain to reach the sick and hurting was indelibly etched into her memory. "As if it were yesterday," she recalled in an interview with a Sioux Falls newspaper about the difficult time she had getting to her patients, "I can still see the hack [coach] that daily met the train each afternoon, laboriously travel passed my house, mired to the hub, requiring two spans of horses to get it to the station at all."[15]

Jenny was proud of the team that hauled her coach through the Yankton countryside. "Their faithfulness and intelligence were amazing," she told the newspaper reporter. "Many times, I have awakened in my rig, safe and sound in the barn after an all-night ride from some country

confinement case." Eventually, the doctor traded in the horse and buggy for a car.[16]

Dr. Murphy had a distinctive look. She was a thin woman who dressed in long black or gray skirts, black jackets, and white blouses. Her hair was fixed in a tight bun, and she routinely topped her outfit off with a man's black hat. She had a masculine way of walking, and her actions were manly as well. She was outspoken and stern and unafraid to take on cases from which others would shy.[17]

Yankton County, like much of the rest of the country in 1917, was dealing with a flu epidemic. The illness claimed thousands of lives. Flu sufferers in Dr. Murphy's care survived the outbreak. She attributed the success rate to a prescribed combination of whiskey and camphorated goose grease, followed by plenty of rest. The process used to create the medication involved boiling the goose fat in a skillet and mixing in cubes of solid camphor. The concoction was then applied to the chest and aching joints.[18]

"In 1919, Dr. Murphy was widely publicized as the first woman ever to garner a seat on a city commission," the October 21, 1951, edition of the *Argus Leader* reported. "She was elected commissioner of streets in Yankton, and during her five years on the board was instrumental in the early day cleanup of taverns, other members of the board noted."[19]

"Her work as Degree of Honor medical examiner in South Dakota began in 1900, and she became the national medical examiner in 1914. In 1922, she dropped her medical practice to devote full time to the organization, until 1940, when Dr. Murphy retired from all duties."[20]

Dr. Murphy passed away on November 3, 1959, at the age of ninety-four.[21]

The Smallpox Scare

Doctors such as Jenny Murphy were well educated in the diseases that threatened the communities where they practiced medicine. Among the framed items posted on the walls of their offices was the National Board of Health bulletin on precautions against the spreading of smallpox, issued in 1901:

It is no doubt wise to magnify the dangers of so dread a scourge as smallpox in order that every precaution may be taken against its spread.

Perfect isolations of the sick. In towns and cities where a suitable hospital has been provided, this is best secured by removal of the sick. In country districts the end may be attained by allowing only nurses and the attendants to visit the sick room, and these to see no other persons during the continuance of their services as such, without having changed their clothes or subjecting themselves to thorough disinfection.

After recovery from smallpox, the patient should not be permitted to go out, or to communicate with other persons, until the crusts have fallen off, and his clothing has been renewed or disinfected.

After death from smallpox, the beds and bed clothes, carpets, curtains, and other articles in the room should be destroyed or disinfected by the method to be hereafter directed. Inasmuch as the bodies of the dead by smallpox are still infectious, they should be disinfected, and public funerals should be avoided.

Cleanliness in and about the dwelling, and ventilations of the latter, afford efficient aids toward the success of other measures to prevent the spread of this and other contagious diseases.

Disinfection of the Articles about the Patient

Disinfect the sheets, towels, handkerchiefs, blankets, and other articles used about the patient, as soon as removed by immersing them in a vessel or tub containing half a pound of sulphate of zinc, or half an ounce of chloride or zinc, or four ounces of sulphate of zinc combined with two ounces of common salt to each gallon of boiling water. Boil for half an hour. The articles should be placed in the solution before being removed from the room. The discharges from the patient should be received in a

vessel containing one of the above solutions, or a solution of half a pound of sulphate or iron in one quart of water.

The bodies of the dead may be disinfected by washing them with the solution of zinc and salt of double strength and wrapping them in a sheet saturated with the same solution mentioned above. It is advised, also, to sprinkle the floor with a solution of carbolic acid and sulphate of zinc to one gallon of water. Neither the sulphate of zinc will stain or injure ordinary articles of clothing.

The Disinfection of the Clothing

Clothing which will not admit to being boiled, and which is too valuable to destroy, may be sprinkled with one of the last-named solutions, or the latter may be applied by means of a sponge, the articles themselves being subsequently exposed to the open air.

Other clothing, such as silks, furs, woolen goods, and the like, to which the above means are not applicable, should be suspended in the room during its disinfection by the method immediately to be explained, and afterwards exposed to the open air. Furniture, pillows, mattresses, window curtains, and carpets should at the same time be exposed to the process. It is advised that the carpets should be fumigated on the floor and the mattresses ripped open for more thorough exposure.

Disinfection of the Home or Infected Room

For this purpose, sulphur is used. The rule is to take roll-sulphur broken into small pieces, place it on a metallic dish resting upon bricks set in a tub containing water, or upon supports laid across the tub, pour a little alcohol upon the sulphur, and ignite it. Then immediately leave the room. Let the doors and windows be tightly closed and kept so for half a day. Then ventilate the home for several hours. One pound of sulphur is advised for one thousand feet of cubit airspace.

Other substances have been advised as disinfectants for the various purposes above alluded to, but those mentioned are cheap, effective, and within reach of all.[22]

Lillian Heath

Wyoming Surgeon

*I had two deep pockets set in front of some garments in which to carry,
among other things, my medical bag and a revolver.*

DR. LILLIAN HEATH

BLOOD GUSHED FROM FIFTY-THREE-YEAR-OLD SHEEPHERDER GEORGE
Webb's head as physician Thomas Maghee eased the man onto a hospital
bed in his office in Rawlins, Wyoming. Dr. Maghee's assistant, Lillian
Heath, covered what was left of the injured patient's nose and mouth
with a chloroform-soaked cloth, and within a few moments, Webb was
unconscious. Lillian helped Dr. Maghee peel layers of bandages and rags
saturated with sanguine fluid from Webb's neck and face. The potentially
fatal wound had been caused by a self-inflicted gunshot. George Webb no
longer wanted to live and, on November 2, 1886, had attempted suicide.

According to the *Colorado Medicine Journal*, Webb had "placed a
shotgun containing a charge of eighteen buckshot in each barrel on his
body, pressed the muzzle under his chin and fired one charge with his
foot."[1] When the gun fired, the concussion knocked him back a bit, and
the ammunition had exploded in his face.

"The chin, lips, nose, anterior portions of the mandible and alveo-
lar border of the superior maxilla, in fact everything from the pomum
adami to the tip of the nasal bone was destroyed," noted the author of
the story in the medical journal.[2] Webb's suicide attempt had taken place
on his ranch some thirty miles from Rawlins. Friends transported him to

9

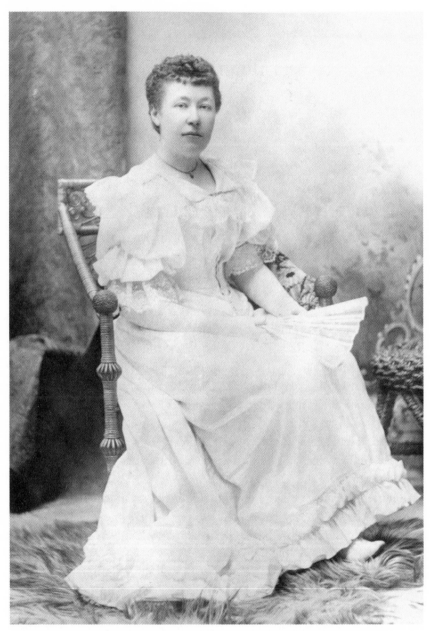

Dr. Lillian Heath. Sub. Neg 2723, Dr. Lillian Heath Nelson, Wyoming State Archives.

Dr. Maghee's office, where Maghee and aspiring physician Lillian Heath cleaned and dressed the wound and prepared the injured man for surgery.

Lillian had been Dr. Maghee's intern for more than four years when Webb was brought to the office, and she'd learned a great deal about medicine during that time. Working alongside Dr. Maghee, she'd helped deliver numerous babies, set broken bones, amputated legs and fingers, stitched torn skin back together, and tended to those suffering from the flu and diphtheria. Webb's case gave her the opportunity to be a part of a groundbreaking medical procedure known as plastic surgery. More than thirty surgeries would be necessary to rebuild Webb's face and nose.

"Once the damaged sections of skin were cut away, the lower jaw bones were removed at the insertions of the second molar teeth," read the article in the medical journal.[3] "The tissues of the cheeks on either side having been incised and loosened, a bridge was thrown across the gaping cavity. The torn ends of the various muscles were then attached to the inferior side of the bridge, union taking place readily."[4] Lillian and Dr. Maghee used sections from the patient's forearms to replace the upper lip. "The septum of the nose was restored from the balls of the thumbs," explained the article, "and the balance of the organ from the small remaining portion of the ala nasi of the left side and from other parts of the hands."[5]

It took several months for Webb to make a complete recovery. According to an interview done with Lillian in 1961, she had provided continual care for Webb, feeding and bathing him and helping him adjust to his reconstructed face. Lillian believed he was resentful that his life had been saved, and he was often difficult to work with as a result. She felt he was better looking after the surgery than before the injury occurred and was not shy about telling him so.

Lillian Heath admitted she inherited her boldness from her father. Born on December 29, 1865, in Burnett Junction, Wisconsin, to William and Calista Heath, Lillian came into the world while her father worked for the Union Pacific Railroad as a painter, but he'd had a great interest in medicine. Although he knew only the basics, he volunteered to help the railroad physician whenever he was needed. Lillian grew up hearing

George Web after reconstructive surgery. Dr. Lillian Heath assisted with a ground-breaking plastic surgery operation in 1886. Sub Neg 9812, Plastic Surgery, Wyoming State Archives.

exciting stories about her father's medical adventures in Rawlins, Wyoming, where the family relocated in 1877.

Lillian realized at an early age she wanted to be a doctor. Although her father was supportive of her desire, her mother believed it wasn't right for women to study medicine. Lillian was determined to pursue a career in the profession despite her mother's objections. She confessed in the interview done by Helen Hubert on file at the American Heritage Center in Wyoming that men were always more accepting of her becoming a doctor than women. "Women were just as catty [about the idea] as they could be," she recalled.[6]

After about five years' training under former army surgeon Thomas Maghee, Lillian set off to attend the College of Physicians and Surgeons in Keokuk, Iowa. She graduated in 1893 along with twenty-two other classmates, only three of whom were women. Lillian's field of expertise was obstetrics. After completing her medical studies, she spent time focusing on childbirth and gynecology. She enjoyed that area of care but admitted in an interview that her specialty was anesthesiology. While working with Dr. Maghee, she'd learned the proper anesthesia to use and how to administer it. "Early on, the practice was to give patients a healthy dose of whiskey first," she explained. "Later chloroform and ether were used. I could administer anesthetics without any ill effects. I never had trouble."[7]

While attending classes at the College of Physicians and Surgeons, she made the acquaintance of Dr. Elizabeth Blackwell. Blackwell was the first woman to earn a medical degree in the United States, and Lillian admired her efforts. The encounter with the pioneer in the profession was brief, but it was one she would remember the rest of her life.

Lillian returned to Rawlins once she graduated and opened a practice. In the interview she did with historian Helen Hubert, Lillian shared she would travel thirty to forty miles away to call on patients. Riding a reddish-yellow sorrel horse and carrying a revolver for protection, Dr. Heath would take care of those in need wherever they might be. One of the patients she responded to that lived far from town was an elderly man suffering from an unknown ailment. When Dr. Heath arrived, she was surprised to find the "sick" individual carrying on about his business

on his ranch as though nothing at all was wrong with him. Lillian examined the man and couldn't find anything out of the ordinary. As the hour was too late to travel back to Rawlins with the specimen she'd collected from the patient, Lillian accepted his invitation for her to stay overnight. During the evening the doctor overheard a conversation the man had with one of his hired help. The ranch hand inquired how his employer was feeling, and the man boasted he was in fine health. The real reason he'd asked Lillian to visit was that he "wanted to see what a lady doctor looked like."[8]

Not everyone was as excited to see a woman physician. Practicing medicine in some locations was hazardous for ladies in the profession. Those who thought it unseemly for a woman to be a doctor considered themselves justified in attacking her. Lillian had spent a summer working at medical clinics in Denver and recalled how dangerous the job could be. According to the doctor, if she had to be out after seven or eight o'clock at night, she would dress in men's clothing. She braided her long hair and tucked the braids under a man's fur cap. The disguise allowed her to make her way around unnoticed.

Some of the male patients Lillian had during her apprenticeship with Dr. Maghee objected to her doing any more than taking their temperatures. She recalled one cowboy who insisted she not be consulted regarding a serious medical condition he was suffering. The years spent on the back of a horse had created problems with his genitals. It was determined he required surgery to correct the issue. "He agreed to the operation but was adamant no women be allowed in the operating room," Lillian recalled in an interview.[9] She administered the anesthesia that put the cowboy to sleep and was checking his vitals before Dr. Maghee moved his bed to the operating room. She had promised the cowboy she wouldn't be in the room during the procedure but would be the one to take care of him before the procedure. While she was checking his heart and monitoring his breathing, the patient woke up. "Who the hell are you?" she remembered the cowboy asking.[10] The sudden way he came out of the anesthesia startled her. She admitted to never being as frightened of any one thing as much in her life. She managed to get the cowboy under again, and the operation proceeded without further incident.

Lillian had difficulties with female patients too. One elderly woman in town frequently asked Dr. Heath to make house calls but had no intention of paying her. The woman was a minister's wife, and Lillian felt her behavior should have been better than the average person's. She only responded to the woman's calls for help a handful of times. Eventually, she refused to continue seeing her because the minister's wife refused to compensate her for her services because she was a woman doctor.

Lillian was a member of the Wyoming Medical Society and the Colorado State Medical Society. She was one of only a few women registered with either organization.

Dr. Heath met her husband, a former soldier and interior decorator, Lou J. Nelson, in Rawlins, and the two were married on October 24, 1898. The couple lived in both Wyoming and Colorado. Together they ran the Ben-Mar Hotel in Lamar, Colorado.

Lillian retired from practicing medicine in 1909 but kept her license active throughout the rest of her life.

In mid-1950 Lillian made national news when the body of an Old West outlaw was discovered in a whiskey barrel coffin in Rawlins. According to the May 13, 1950, edition of the *News*, "the discovery was made by workmen who were digging an excavation for a new downtown store building."[11]

The barrel contained a number of bones, including a skull with the top sawed off.

A Rawlins pioneer recalled that Dr. Lillian Heath owned the top of Big Nose George's skull. The top had been given to her by Dr. John Osborne who dismembered the body in 1881.

Big Nose George was George Manuse, alias George Parrott, who in 1880 attempted, with a few accomplices, to derail a Union Pacific train hauling a railroad pay car. The plot was discovered, and the outlaws fled to Rattlesnake Canyon at the foot of Elk Mountain.

Deputy Sheriff Bob Wooderfield [sic] of Rawlins was shot and killed when he came upon the outlaws' hiding place. Big Nose was captured and later sentenced to be executed. He was taken from the jail by four or five men and lynched.[12]

At the age of eighty-nine, Lillian was invited to tour the Denver hospitals to observe the most modern medical techniques of the day. The August 30, 1955, edition of *The Daily Sentinel* included an interview with Lillian about the trip to Colorado and all she would be doing:

> Dr. Heath and her husband were surprised on their arrival at Denver's Stapleton Airfield with a group of former Rawlins people on hand to greet them. Other greeters included Denver's two senior women medical practitioners, Dr. Ethel Fraser and Elise Pratt.
>
> Dr. Franklin Yoder, Wyoming State Health officer, joined the doctor and her husband at Cheyenne and accompanied them on the tour of Denver. Officials at the Colorado State Medical Society took them for a brief drive around Denver Sunday before Dr. Heath and her husband retired.[13]

Dr. Lillian Heath passed away on Sunday, August 5, 1962. She was ninety-six years old.

Groundbreaking Plastic Surgery

In early November 1886, Dr. Lillian Heath assisted Dr. Thomas Maghee in a delicate facial reconstruction operation. Fifty-three-year-old sheepherder George Webb had tried to kill himself with a shotgun. According to historical records at the Wyoming State Archives, Webb was reclining on his bed when he placed a shotgun containing a charge of eighteen buckshot in each barrel on his body, pressed the muzzle under his chin, and fired one charge with his feet. He was transported from his ranch, where the incident had occurred, to the hospital in Rawlins, Wyoming, thirty miles away. Dr. Maghee performed the surgery, and Dr. Heath administered the chloroform for anesthesia. Dr. Maghee described the work that was done with Dr. Heath's help in Webb's medical records:

The chin, lips, nose, anterior portions of the mandible and alveolar border of the superior maxilla, in fact everything from the pomum adami to the tip of the nasal bone was destroyed. The left side of his neck, beyond the protection of his heavy beard, was badly burned by powder . . . [T]he wound was cleansed of impacted, partly burned whiskers, bloodclots [sic], clothing, etc. When sloughing ceased the powder-burnt ends of the lower jaw bones were removed at the insertions of the second molar teeth. . . .

While a very respectable nose resulted [after the surgery], the fact that all such restorations contract and shrink away, determined the necessity to dissect a large flap from the forehead, turning it downward over the nose, the edges were attached to the vivified integument along the sides of the nose and the tongue like projections taken from the hairy scalp bent over and fastened to the lip as an addition to the septum. . . . The material to replace the upper lip and fill below the bridge was taken in several sections from the forearms by making parallel incisions an inch and three quarters apart, across the dorsal aspects, loosening the included tissue the width of the arm from the fascia, a piece of muslin bandage being then inserted under the dissected portion to prevent reunion.

When sufficient thickening of the flap had occurred, it was severed entirely on the ulnar side, and showed two thirds on the radial; thickening and vascularization increased and in a couple of days the arm was placed in a convenient position across the face and, with the wrist and hand,

was securely fastened with adhesive and bandage to strips of sheet iron forming a cap or head dress, the arm being thus rendered immovable. The flap was then turned up and secured in place to vivified tissue, with fine silk sutures.

The pedicle was not severed, the blood supply remained normal. The nose, at first enormous, shrunk one third of its size as I expected it would, remaining of proper proportions, and fairly good shape, blushing and paling with the rest of the face. For some weeks hair continued to grow from them septum attaining a length of two inches, but as usual in such cases, fell off gradually.

A hard nodule began to form where the Digastric and other muscles were attached to the bridge processes extend from the ends of the inferior maxillae until an arch was completed, somewhat foreshortened but enabling the patient to wear artificial teeth if desired. The mount was one sided and did not close properly, quite a nick remaining in the side of the upper lip. A bistouri [sic] was thrust through the cheek where the corner of the mouth should be, carried forward enlarging the opening, the cuticle removed from the edges of the lips, the remains of the notch in the upper lip closed, red membrane from inside the mouth brought out and with fine sutures fastened to the edge of the vivified surface in such manner as to simulate the natural outward roll of lips as nearly as possible.

The mouth was closed properly and was natural in appearance.

The denuded portions of the forehead, cheeks, hands, and forearms cicatrized rapidly. Whiskers grew abundantly on the lips and chin. There were thirty-nine operations under profound chloroform anesthesia. The first on November 12, 1886, and the last on April 27, 1887.

I adopted the methods of many preceding operators, as will be seen, but I believe that I am original in not severing the pedicle, preserving circulation, and preventing the too great shrinking and discoloration of the nose. Also, in applying one graft after another as quickly as each adhered, cicatrization and contraction proceeding simultaneously, producing more symmetrical and satisfactory results.

Webb returned to sheepherding and was seen in Los Angeles in 1905. The scars have about disappeared, the nose is natural in size, shape, and color.[14]

Eliza Cook

First Licensed Woman Doctor in Nevada

For forty years she practiced medicine in this valley, and many a man
now with a family of his own recalls being summoned in the middle
of the night to saddle his horse and go across the valley for Dr. Cook.
NEVADA STATE JOURNAL, JUNE 9, 1946

AN ADVERTISEMENT THAT APPEARED IN THE MAY 5, 1892, EDITION OF
the *Reno Gazette Journal* caught the attention of many residents in the
northern Nevada town. It read as follows: "Dr. Eliza Cook may be
consulted at her office in rooms 25 and 26 at the Golden Eagle Hotel
between the hours of 9:30 to 11:30 A.M. and from 2 to 4 o'clock P.M."[1]

The reason the advertisement drew so much attention was the fact
that a woman physician had posted it. The idea of a woman doctor was
still a relatively new one in the Old West in the late 1800s. A female
physician publicizing her services was also unique. Dr. Cook was confi-
dent her practice would benefit the community and was willing to risk
criticism from those who believed the bold act was as out of place for a
woman in the medical profession.[2]

Eliza's desire to become a doctor began when she was fourteen years
old. She was a voracious reader, and one of her favorite books when she
was young was of a country doctor and the individuals he helped. From
that point on, she was consumed with the dream of studying medicine.[3]

Eliza Cook was born in Salt Lake City, Utah, on February 5,
1856. Her parents, John and Margaretta, moved to America from

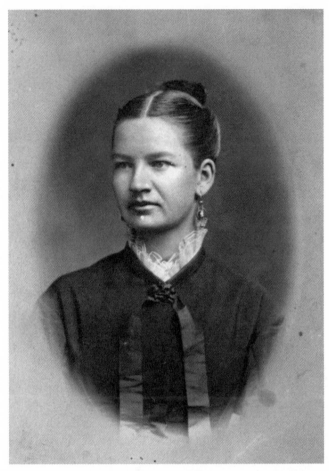

Dr. Eliza Cook. Courtesy of Douglas County Historical Society, Nevada.

England in the 1850s. Not long after her father passed away in 1870, Eliza, her mother, and her sister relocated to Carson Valley. Nine years after the Cooks arrived in Nevada, Eliza was presented with an opportunity to be part of the medical field. Dr. H. W. Smith, a prominent physician in Genoa, Nevada, hired her to help care for his wife. Mrs. Smith, who had just had a baby, was suffering with puerperal fever, a disease that primarily affects women within the first three days after childbirth. It progresses rapidly and causes acute symptoms of severe abdominal pain, fever, and debility. Dr. Smith was so impressed with Eliza's natural ability

and the way she tended to the patient, he suggested she study with him as a preparation for college.[4]

Eliza's apprenticeship with Dr. Smith lasted six months. At the conclusion of her time at the practice, she entered what would eventually be known as Stanford Medical School. She graduated in 1884 with her doctor of medicine degree. In 1891 she continued her education by entering the Woman's Medical College of Philadelphia. Her postgraduate work was done at an academy in New York.[5]

Eliza Cook returned to Carson Valley after completing her studies and hung out a shingle formally announcing there was a new doctor in town. She was the first licensed woman doctor in the state of Nevada. Her career in the region spanned four decades. She looked after patients who had contracted scarlet fever, typhoid, and diphtheria. She delivered numerous infants, mended broken bones, and stitched dangerous wounds. The top buggy she drove to make house calls was always a welcomed sight.[6]

Dr. Eliza Cook in the doorway of her home south of Genoa, Nevada. Courtesy of Douglas County Historical Society, Nevada.

Dr. Cook was a supporter of women's right to vote and an ardent member of the Woman's Christian Temperance Union. She served as the state president for the organization from 1896 to 1901. She was outspoken and believed the notion men should rule over women was unjust.[7]

She never married and lived happily alone in a home she had built for herself in Genoa. She enjoyed gardening and reading. The articles she routinely read in *Scientific Monthly*, the *Pathfinder*, the *New Republic*, and *Survey Graphic* kept her up to date on political matters and advancements in medicine.[8]

Not only was Dr. Cook a student of many medical journals, but she was also a contributor. Eliza penned several articles about the medical profession and the need for more women to enter the field.[9] One of Dr. Cook's articles was reprinted in the October 14, 1895, edition of the *Observer*:

The college for the medical education of women founded by the Legislature of Pennsylvania was triumphant. The act by which it was founded conferred upon it all the privileges enjoyed by any other medical school in the state. It was Elizabeth Blackwell who first received the degree of Doctor of Medicine at Geneva College. She went on to pursue her medical studies in Paris and was a candidate for the professorship of surgery, and other ladies offered themselves to fill the other chairs.

At first sight, this seemed an extraordinary proceeding and quite a startling novelty. But there remain sufficient grounds for women to pursue careers in medicine and succeed in the field. For one thing, it opens a new field for the employment of women profitably and usefully and any enlargement of the field of honorable occupation for the sex tends to her own social advancement, as well as that of humankind. Looking at the profession of female doctor, there is nothing unreasonable in it, but the contrary, however much it may be at variance with existing usages. In many of the diseases to which women are subject, the care of their own sex seems perfectly consistent with all notions of delicacy and modesty.

Not half a century ago, women were very extensively, indeed almost exclusively, employed to attend the sex only under certain circumstances. There were some male doctors who were indignantly against

the substitution of medical men in such cases, as a mark of our declining manners and morals. Women were then displaced because of their want of scientific culture, and the men took their place. Slowly, over time, women were offered the same degree of culture, making them equally competent to officiate in such cases as male surgeons.

There are now a growing number of women throughout the world in extensive practice, who have even been in difficult cases, called in by medical men themselves, in consultations. These ladies command a high degree of respect and maintain a high social status. Books such as the *Moral History of Women* by Earnest Legouve advocate for a wider sphere of operations for women in the field of medicine. He asked, "Why should not certain specialties of the medical art be accessible to women? Operative surgery, a science positive and material, requires boldness and of execution, a firmness of hand, a certain force of insensibility, which naturally excludes women from it, but medicine is a theoretical science, depending on observation, and who will contest the superiority of women as observers? As a practical science it depends upon the knowledge of individuals, and who understands so well as a woman the peculiarities of individual character? Women with their marvelous perception of individuality would bring to the treatment of the sick a subtle divination—a tact in management of the patient's mind, to which mend could never attain."[10]

Dr. Cook retired from practicing medicine in 1922. She died at her home in Carson Valley on October 2, 1947. She was laid to rest at the Mottsville Cemetery in Gardnerville, Nevada.[11]

The Sixteen Commandments of Hygienic Rules for the Care and Management of Infants

Medical Gazette, 1882, Volume IX
The Boston Female Medical College condensed sixteen propositions as the most important hygiene rules for the care and management of infants. They were reproduced and distributed to doctors such as Romania Pratt with the sincere hope that they hand them out to mothers and nurses who would commit them to memory and observe them as faithfully as the Ten Commandments of Holy Writ:

During the first year the only suitable nourishment for an infant is its own mother's milk, or that of a healthy wet-nurse. Suckling should be repeated every two hours—less frequently at night.

When it is impossible to give breast milk, either from the mother or a suitable nurse, cow's or goat's milk given tepid, reduced at first one-half by the addition of water slightly sweetened, and after a few weeks one-fourth only, is the next best substitute.

In giving milk to an infant always use glass or earthen-ware vessels, not metallic ones, and always observe the most scrupulous cleanliness in their management, rinsing whenever used. Always avoid the use of teats of cloth or sponge, so frequently employed to appease hunger or quiet crying.

Avoid carefully all those nostrums and compounds so liberally advertised as superior to natural food.

Never forget that artificial nourishment, whether by nursing-bottle or spoon (without the breast), increases to an alarming degree the chances of producing sickness and death.

It is always dangerous to give an infant, especially during the first two months of its life, solid food of any kind—such as bread, cakes, meats, vegetables or fruit.

Only after the seventh month, and when the mother's milk is not sufficient to nourish the child, should broths be allowed. After the first year is ended, then it is appropriate to give light broths or paps, made with milk and bread, dried flour, rice, and the farinaceous articles, to prepare

for weaning. A child ought not to be weaned until it has cut its first 12 or 13 teeth, and then only when in perfect health.

A child should be washed and dressed every morning before being nursed or fed. In bathing a child temper the water to the weather, carefully cleanse the body, and especially the genital organs, which require great cleanliness and care; and the head should be carefully freed from all scabs and crusts which may form. Where the bellyband is used it should be kept up on for at least one month.

An infant's clothing should always be so arranged as to leave the limbs freedom of motion, and not to compress any part of the body.

An infant's clothing should be studiously adapted to the weather, avoiding at all times exposure to the injurious effects of sudden changes in the temperature without proper covering; but nurseries and sleeping apartments should invariably be well ventilated.

An infant should not be taken into the open air before the fifteenth day of birth, and then only in mild, fair weather.

It is objectionable to have an infant sleep in the same bed either with its mother or nurse.

No mother should be in too great a hurry to have a child walk; let it crawl and accustom itself to rising on its feet by climbing on articles of furniture or assisted by the arms of a careful attendant. Great care should be taken in the too early use of baby-wagons, etc.

No trifling ailments in infants, such as colics, frequent vomiting, diarrhea, coughs, etc. should be neglected—a physician's advice should be at once obtained.

In cases of suspected pregnancy, either of mother or nurse, the child should be weaned at once.

A child ought to be vaccinated after the fifth month, or earlier should smallpox be prevalent.[12]

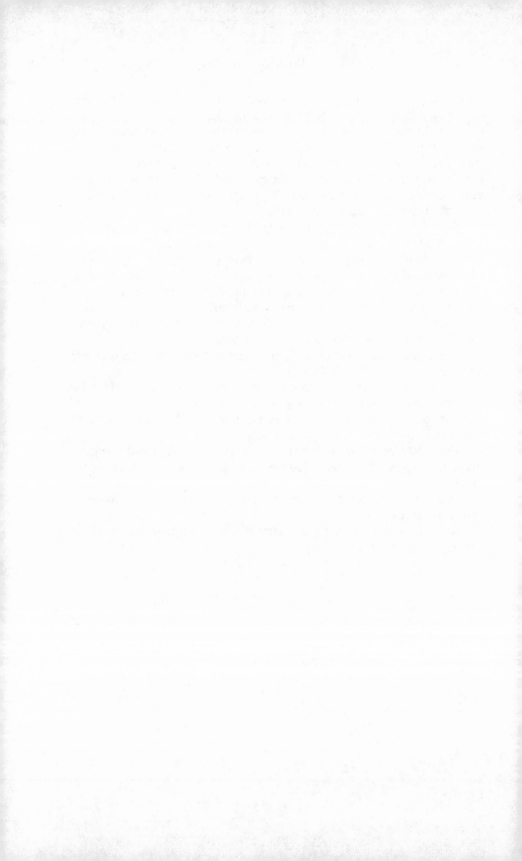

Emma French

The Railroad Doctor

She could take out a bullet, sew up a knife wound, fend off Indians, and exist on nothing but hope. It was as if life had decided she didn't need any favors.

AUTHOR JUANITA BROOKS

SHE CUT. THE BULLET THAT SLAMMED INTO THE INJURED COWBOY'S chest had come to rest next to his lungs and had to be removed. Dr. Emma French widely opened the wound to extract the slug. Her hand was steady and eyes sharp. She was no stranger to performing complicated medical procedures under pressure. A woman in the profession in the 1890s was not readily accepted, and some ran the risk of being beaten if they were discovered practicing medicine. As this was an emergency, Dr. French was given a free hand to do whatever she could to save the two patients before her. A pair of cowboys had gotten into a drunken brawl and were seriously hurt as a result. One had been shot, and the other cut to pieces with a knife. After tending to the gunshot victim, she turned her attention to the man with the knife wounds. She put back into place intestines and muscle and stitched the inebriated soul together.[1]

The incident occurred in Winslow, Arizona, in December 1892. A respected male physician visiting from Santa Fe, New Mexico, was called to the scene first, but after examining the two men, he decided it was hopeless and left them to die. The authorities decided to send for Dr. French to see if she could save their lives. Within two weeks of the

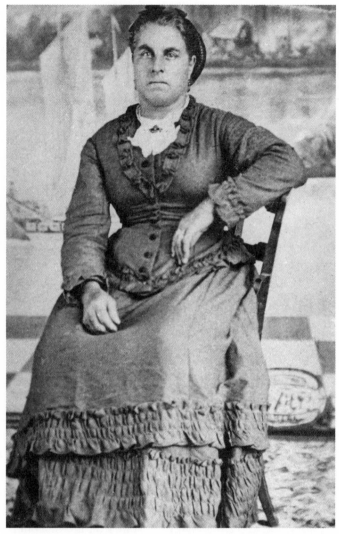

Dr. Emma French. Arizona Historical Society, Emma Batchelder Lee, 1285.

doctor operating on the mortally wounded men, both were back on their feet and back in the saloon.[2]

Emma French was born Emma Batchelder in Uckfield, Sussex County, England, on April 21, 1836. Her poor parents were Mormon missionaries who wanted their two daughters and son to be prosperous

28

and follow the ways of the church. Emma had studied medicine working as an apprentice for a local physician and wanted to pursue the profession. Her parents had other ideas. At the age of twenty-one, Emma took her parents' advice to move to Zion, the location Mormon believers thought was the heavenly kingdom. Utah was considered Zion. In 1859 Emma and her best friend, Elizabeth Summers, traveled to America. Their passage was paid for by the Perpetual Emigration Fund of the Church of Latter-Day Saints. Emma and Elizabeth traveled steerage on the ship from Liverpool to New York and, from there, to the end of the Rock Island Railroad in Iowa City. They were among the four hundred plus people in the handcart company train under Captain James G. Willie departing on July 15, 1856.[3]

The trip to Utah was expected to take a hundred days, a little more than three months. Members of the Willie company, like those in similar companies, walked ten miles a day. It didn't take long for the handcarts to begin showing wear, and stops had to be made to repair the vehicles. Captain Willie insisted the problem with the carts was the load of goods piled inside them. When the company reached Fort Laramie, Wyoming, in mid-September 1856, the leader of the tour ordered the travelers to leave behind much of their nonessential provisions and personal belongings. Emma refused to obey the captain's directive. In her cart was a copper washtub containing clothing that once belonged to her mother. Emma proved her defiance by sitting on top of the tub and refusing to leave.[4]

Emma was confident she could join the Mormon handcart company that had departed ten days after Captain Willie's group. While waiting for the next company, Emma was able to support herself by doing laundry and mending soldiers' uniforms. When the next handcart company arrived at the post, she acted as midwife for those ladies giving birth on the journey. Fellow travelers noted how caring and self-assured she was at delivering babies. She did, indeed, join the next handcart company making its way to Salt Lake City and arrived at the destination on November 30, 1856. She had walked more than fourteen hundred miles.[5]

On December 27, 1857, Emma met John D. Lee, a prominent church leader. The couple married less than two weeks after being introduced.

She was his sixteenth wife. Lee moved Emma into his home at Harmony in southern Utah. During her time there, she received the midwife's training given to all Mormon women. She learned about surgery, disease diagnoses, and treatment from the many medical books on hand. She was fascinated with medicine and the specific drugs created to cure illnesses.[6]

Emma and John had four children while living in Harmony, two boys and two girls. She also helped raise the son of her husband's eighteenth wife, Ann Gordge. For a time Emma, John, and their family were content with life in Utah, but an incident that occurred with her husband prior to their being wed threatened their happy ever after.[7]

In September 1857 John Lee had been involved in the Mountain Meadows Massacre, the killing of western emigrants near Mountain Meadows, Utah. The emigrants, numbering more than 130, were on their way from Arkansas and Missouri to southern California. While camping in the valley of Mountain Meadows in Washington County, they were attacked by Native Americans and, it is alleged, by Mormons disguised as Native Americans. They held their ground for three days, when, under promise of protection by John Lee, a Native American agent at the time, they left their barricade of wagons, whereupon the attack was renewed and all 130 plus adults were slaughtered. Seventeen children were allowed to live and were distributed among Mormon families.[8]

In early November 1874, seventeen years after the horrific events at Mountain Meadows, John Lee was arrested for murder by a deputy US marshal and placed in jail at Camp Cameron near Beaver, Utah. His first trial resulted in a hung jury. The second trial, held in September 1876, resulted in a conviction.[9]

Emma championed her husband throughout both trials and paid for the defense attorney by selling their livestock and, with some of the funds earned, by operating a ferry John had purchased on the Colorado River in Arizona.[10]

On March 23, 1877, John Lee's death sentence was carried out by his choice of a firing squad. According to the March 23, 1877, edition of the *Green-Mountain Freeman*, "Lee was taken to his place of execution between 10 and 11 o'clock in the forenoon and seated on his coffin about twenty feet from the five men who were to shoot him."[11] After the

marshal read the order of the court, he asked Lee if he had anything to say before he was executed. "I wish to speak to that man," Lee told the law enforcement agent.[12] Lee pointed to a photographer nearby setting his canvas to take the accused's picture. "I want to ask you a favor. I want you to furnish three of my wives a copy of the photograph, a copy to Rachel and Sarah C. and Emma B."[13] The photographer agreed. Not long after the exchange, Lee was shot and killed.[14]

Emma took over operations at the ferry after Lee's execution. The business paid well, and she supplemented the ferry income with a small herd of cattle. Plans to live a peaceful life raising her children and working on the river were dashed when Mormon church members overtook the ferry and Emma's home. Members of the Sixth US Cavalry helped move the widow and her family, their personal belongings, and the cattle she owned to Sunset City, Arizona, three miles east of Winslow.[15]

Emma had no intentions of staying long in Sunset City. She was contemplating where to settle and how she and her children would get there when she met Franklin French. She had met Franklin while she was working at the ferry, several months prior to their Arizona encounter. The tall, heavily built, dark-complected man was prospecting the Grand Canyon country when he and Emma were first introduced. Franklin noticed the widow was struggling and offered to lend a hand. He would help drive her cattle wherever she wanted to go. Franklin and Emma and her brood traveled south to a railroad town known as Snowflake. Emma and Franklin fell in love with each other on the journey, and the two were married on August 8, 1879. Franklin resumed prospecting, and Emma tended to the children, home, and livestock and offered her services as a doctor to the community. She had few patients at first, but an unfortunate accident in the summer of 1880 brought her more business than she cared to have.[16]

A sudden torrential flash flood raged down Cottonwood Wash in mid-August 1880. Pushing across the region, it demolished a long bridge being constructed by the Atlantic & Pacific Railroad. So swift was the twenty-foot-high wall of muddy water that workmen on the structure had no warning of approaching disaster. Men were tossed into the deluge and smashed wreckage of big timbers.[17]

As the head rise fell rapidly after losing the power plunging into the Little Colorado River, victims were pulled out of the mud. The dead were placed in one railroad contractor's tent for burial and the injured, in another. Steel rails ended forty miles eastward, and no emergency train could get to the scene. There was no doctor or nurse at the main construction camp anyway. Unless attended to quickly, some of the worst injured would surely die.[18]

In this desperate situation, one of the gang bosses said to the civil engineer in charge, "Why don't you send a rig down to their ranch for Mrs. Emma French? She learned doctoring the hard way, but there's none better."[19]

Leaping at this straw of hope, a man was dispatched in a buckboard to get her. On arrival Emma went right to work. First aid was given to those with broken arms and legs and internal injuries. Some of the railroad workers who were not injured helped Emma splint fractured limbs. After the injured were taken care of, she remained to doctor them during recovery.[20]

By the time the broken leg cases were able to hobble around some, a mysterious fever broke out among the workmen. Under Emma's supervision everyone recovered.[21]

In 1881 the Atlantic and Pacific Railroad decided to extend its road construction to Hardy, twelve miles east of Winslow. They built a two-story station house in Hardy for railroad staff to conduct their business. Section workers kept to the upper floor, while Emma used the first as a hospital. Her practice thrived.[22]

In addition to caring for those in the Atlantic and Pacific Railroad's makeshift hospital, Emma traveled from Gallup, New Mexico, to Flagstaff, Arizona, to help railroad employees working up and down the line and camping in remote locations. Railroad executives transported Dr. French to her patients in a special car. A new hospital was built in Winslow in the late 1880s, and Emma was hired to be a part of the staff. Not only had she tended to the hundreds of railroad surveyors, tracklayers, and ranchers in the region, but she had also helped deliver numerous children to railroad employees' wives and the wives of Native Americans living nearby.[23]

Emma was always ready to help when someone was sick or hurt. She kept her medical bag near the front door and the uniform she wore while on the job laundered and pressed. She was a fanatic about cleanliness and insisted her instruments and examination room be routinely scrubbed and sterilized.[24]

In 1891 an epidemic of diphtheria struck the Mexican section of Winslow. It spread rapidly, and the afflicted were attended by Dr. French. For six weeks, she administered vaccines and cared for men, women, and children suffering from the disease.[25]

Emma shared her medical expertise with the Navajos who lived in the area. Many Navajos suffered with an ocular disease known as trachoma. The infection was contagious and had the potential to cause blindness. Emma taught them the importance of keeping faces clean and dirty hands away from their eyes. She also supplied them with clothes and food whenever needed.[26]

Dr. Emma French died unexpectedly on November 16, 1897, at the age of sixty-one. She spent what would unknowingly be her last moments with her husband, discussing his latest prospecting trip. She excused herself to make their lunch and collapsed on the way to the kitchen. An article about Emma's passing in the November 27, 1897, edition of the *St. John's Herald* noted, "She was filled to overflowing with the milk of human kindness. No matter how inclement the weather, or what hour of the day or night, she was always ready to respond to the call of the afflicted, whether rich or poor."[27]

Emma's funeral was held at her home and was a grand celebration of life. In addition to the many friends and loved ones, in attendance were the Santa Fe Railroad officials and county and territorial leaders. Railroad officials ordered all trains passing through Winslow at the time of the service to stop for a full minute out of respect for the doctor's contributions. Engineers driving the trains into and out of the yard did not sound the train's whistle or bells for the same reasons.[28]

Emma's tombstone reads as follows: "Mother at rest. Emma B. French. Born in Uckfield, Sussex County, England, April 21, 1836. Died November 16, 1897. Dr. French."[29]

Eye Care

In the mid-1890s, Dr. Emma French came to the aid of Navajo Indians in northern Arizona who were suffering with trachoma. The Mayo Clinic defines trachoma as a "bacterial infection that affects the eyes."[30] The disease is "contagious [and spreads] through contact with the eyes, eyelids, and nose or throat secretions of infected people."[31] Left undetected, it can lead to blindness. Dr. French prescribed regular washing of the hands, face, and eyes to combat trachoma.

Dr. French wasn't the only female doctor concerned about the proper care of eyes. Dr. Caroline Parker, a physician working in the field of eye care in the 1890s, shared her own idea for better eye health in a paper she wrote, titled "Optic Sanitation." The paper appeared in the May 27, 1891, edition of the Indian Medical Gazette. The following were the rules she listed for the better care of the eyes:

Avoid reading and studying by poor light.

Light should come from the side and not from the back or the front.

Do not read or study while suffering great bodily fatigue or during recovery from illness.

Do not read while lying down.

Do not use the eyes too long at a time for near work, but give them occasional periods of rest.

Reading and studying should be done systematically.

During study, avoid the stooping position, or whatever tends to produce congestion of the head and face.

Select well printed books.

Correct errors of refraction with proper glasses.

Avoid bad hygiene conditions and the use of alcohol.[32]

Bessie Efner

Open Range Doctor

I enjoyed the goodwill of the people among whom I lived and was known as the only doctor between Cheyenne and Pine Bluffs.

DR. BESSIE EFNER, 1912

TWENTY-FOUR-YEAR-OLD DR. BESSIE EFNER PEERED THROUGH THE dusty windows of the passenger car on the Chicago, Burlington, and Quincy Railroad at the endless Wyoming prairie. Sagebrush and buffalo grass dotted the landscape. The tough, tenacious plants emitted a peculiar, pungent odor that wafted through the opened windows next to the seats across the aisle. As the train slowed to a stop, Bessie gently woke the three redheaded girls sleeping on either side of her, their heads resting on her shoulders and in her lap. Ina was thirteen, Elsie was twelve, and Reta was five. The children had been living with Bessie in Sioux City, Iowa, since their parents tragically died in 1904. She struggled to care for her nieces on the modest salary she earned at her small practice in Moville, Iowa, eighteen miles east of Sioux City. The chance to be a better provider had inspired her to travel west.[1]

Thousands of young farmers and aspiring ranchers had rushed to take advantage of the federal government's offer of free land to anyone who wanted to settle west of the Mississippi. As a result, new communities had sprung into being throughout sparsely populated areas like Wyoming. Sections of land in those new communities had been set aside for people who supplied essential services, such as teachers, ministers, and

Dr. Bessie and her graduating class of the medical school, 1895.
Public Domain.

physicians, to build homes. Bessie was encouraged to come to Laramie County, Wyoming, by promoters with the Union Pacific Railroad Company. She was promised a homestead and the opportunity to establish a lucrative medical practice in a spot in the country lacking a doctor. Two months after the house Bessie had built was completed, she moved her family to Carpenter.[2]

When the train had come to a complete stop, Bessie gathered her nieces and belongings and made her way to the exit. Beyond the doors she expected to see a modest depot, one showing a comfortable resistance

to innovation. There wasn't anything at all to see when she and the girls disembarked on December 15, 1907. The train had stopped at what was to soon become Carpenter, but at that time, there was nothing.[3]

Bessie scanned the endless open range stretched in front of them. In the near distance, she saw a wagon quickly traveling toward her and the girls. Beyond that, some two miles out, was Baxter Ranch. "And so this is Wyoming, my new home," Bessie said out loud to no one in particular, "the glamorous West of cowboys and cattle about which I have heard and dreamed so much."[4]

After the driver of the wagon introduced himself and apologized for being late, he explained he was on orders from the town founders to take the new doctor to her home. Bessie and her nieces helped load their modest belongings onto the vehicle, climbed aboard, and, in a moment, were on their way. Bessie listened as the train's panting engine gained steam and started down the track. She looked back just as it pulled away from where they had all once been standing. Reta grabbed her aunt's hand and squeezed. Bessie turned toward the five-year-old and smiled. The doctor then set her sights on what lay ahead.[5]

Bess "Bessie" Lee was born on March 28, 1873, in Galesburg, Jasper County, Iowa. Her mother was Priscilla Templeton (a niece to Robert E. Lee), and her father was a third-generation doctor named William Efner. In addition to her father, grandfather, and great grandfather having a career in medicine, Bessie's brother and uncle were also physicians. Her love for the profession began at eight years old. She enjoyed spending time with her father and watching him work. By the time she was a teenager, she was assisting him in his office by preparing prescriptions and treating patients' minor injuries. When Bessie graduated from high school in approximately 1889, she knew she wanted to follow in her father's footsteps and become a doctor. The realization of such a dream seemed far-fetched. Young women like herself were expected to marry and have families. Their aspirations were to center solely on being wives and mothers.[6]

For a time, Bessie tried to conform to Midwestern society's expectations. She was pursued by one of Galesburg's most eligible bachelors, a banker's son who showed great promise in the field of finance. He

proposed, but she postponed giving him an answer. Although she knew the sincere desire of her heart, she wanted time to think. While Bessie was wrestling with the decision, a family friend who recognized Bessie's talents suggested she go to college and study medicine.[7]

The recommendation helped Bessie clearly see what she needed to do. Before breaking the news to the man who'd asked her for her hand in marriage, she spoke with her father about the possibility. Dr. Efner was surprised to learn his daughter had such ambitions. He had assumed she wanted to get married. After explaining the years of commitment that accompanied the pursuit to become a doctor and warning her of the many people who opposed a woman in the field, he gave her his blessing and promised to do everything he could to help her.[8]

In September 1890 Bessie enrolled at Morningside University in Sioux City, Iowa. Not long after she'd settled into school and begun attending classes, she received a letter from home informing her that the gentleman who wanted to marry her had married another. "I was hurt in my pride but now felt absolved from all obligations, and it removed a most serious obstacle that had stood in the way of my goal," Bessie later wrote in her memoirs.[9]

Bessie excelled at school and graduated with honors. Before she could continue her education, she needed to earn money for tuition to the Sioux City School of Medicine. She took a job teaching for a year to earn the funds needed to carry on. Bessie was one of only two women in the class of hopeful physicians attending the prestigious institution. Male students referred to her and Clara McManus as "hen medics."[10] They were tolerated by the men but not encouraged. Bessie and Clara were regarded as unfit for the medical profession simply because they were female.[11]

Among the many courses Bessie was required to take were pathology, bacteriology, histology, obstetrics, and internal medicine. A handful of the professors Bessie studied under proved to be inspirations. In addition to being teachers, they were also surgeons who treated their patients with dignity and respect. While interning at their medical offices, Bessie learned the importance of making the sick and hurting feel at ease.[12]

Of all the classes Bessie had, anatomy served to be the most meaningful to her. "It opened my eyes to the wonders and complexities of the human body, the most wonderful organism and machine in the universe," she recalled years later.[13] "Man in his very being is the mystery of mysteries. No one can fully understand him, and no one has expressed this more beautifully than the psalmist who said: 'I will praise Thee, for I am fearfully and wonderfully made; marvelous are Thy works, and that my soul knoweth right well.'"[14]

Time in the anatomy lab posed a problem for Bessie. She struggled in the beginning with dissecting cadavers. Many of the subjects were derelicts, drunks, drug addicts, or prostitutes, whose bodies went unclaimed when they passed away. The thought of the disenfranchised dying alone, the smell associated with the procedure, and the spectacle of fellow students huddled around the remains like vultures surrounding a carcass were difficult to handle. In time Bessie learned to adjust to the necessary task, but it was a chore.[15]

Prior to graduating from medical school, Bessie was granted an opportunity to intern at a hospital in Sioux City run by the Sisters of Mercy. She enjoyed her time working with the nuns and believed the experience added greatly to her education. When Bessie received her degree in 1894, she made a point of sharing with fellow graduates how grateful she was to have had the privilege to train at the Sisters of Mercy medical facility.[16]

Having taken the Hippocratic oath and with degree in hand, Bessie set her sights on passing the state board examinations. Her test scores were among the highest of all aspiring doctors in the area. With certification in hand, Bessie struck out on the most difficult part of her journey, that of finding a place where a woman doctor could find employment. Something her father told her before she left for college echoed repeatedly in her head, "Even if you graduate from medical school, you may not be able to practice your profession because society will not accept you."[17] She knew the odds were against her, but she was determined.[18]

When Bessie learned the small town of Hinton, twelve miles away from Sioux City, Iowa, did not have a doctor in its community, she decided to open a practice there. She borrowed money to make the move,

rent office space and a place to live, and purchase supplies and equipment. She had a sign painter stencil the name "Dr. B. L. Efner" on the door leading into the office and then waited for patients to come.

After several weeks, a frantic young farmer arrived on the scene. He'd driven his horse and buggy to town to find a doctor to help his wife who was in labor. The man had given the name on the door a quick glance and wrongfully assumed that Dr. B. L. Efner was a man. The soon-to-be father was surprised when Bessie introduced herself as the doctor. "Well, I'm looking for a real doctor, like other doctors," he explained.[19] Bessie informed him there was no other doctor in the immediate area besides her. She assured him that she was qualified, and he finally agreed to take her to his wife.[20]

The expectant mother was just as stunned as her husband to learn Bessie was a doctor. Bessie sat beside her on the bed and shared her background and love for medicine, and the woman soon agreed to let the doctor help her. Dr. Bessie delivered the couple's son without complications.[21]

The successful delivery of the little boy led to Bessie being entrusted to help a young man suffering with pneumonia living on a farm eight miles from town. Treating pneumonia was complicated before the invention of penicillin. Various treatments had to be employed before the right one was found. Dr. Bessie was attentive to her patient, refusing to leave his side until his fever broke.[22]

"While working on this case, I noticed that the boy's little sister, about seven or eight years old, had been watching me with unusual curiosity, following every movement with a sort of whimsical expression on her face," Bessie later recalled. "But I was so busy with her brother that I could pay no attention to her. As I was about to leave the room, she ran to her mother and in a quite audible whisper said to her: 'Mother, isn't that a funny doctor? He has no beard and wears dresses like a woman.'"[23]

The illness finally passed, and the teenager slowly began to improve. Both the successful treatment of the young boy and the delivery of a baby demonstrated to the citizens of Hinton that Bessie was a competent physician. The doctor went from having no one visit her office to a steady flow of people needing care. Bessie's fees were modest. Office calls

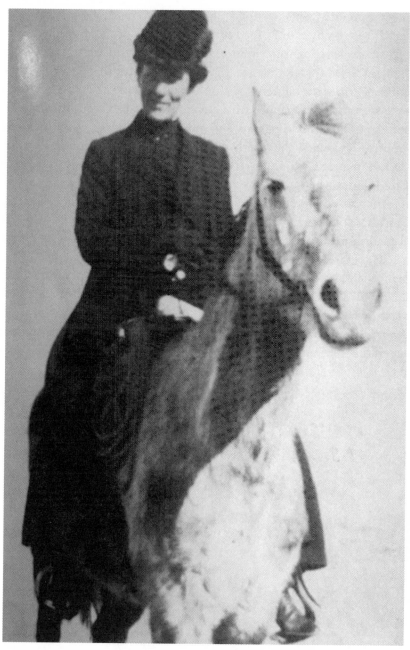

Dr. Bessie often rode several miles to make house calls. Public Domain.

ranged from fifty cents to a dollar; house calls were $1.50 during the day and $2.00 at night. She charged fifty cents a mile for calls outside town.[24]

Just as the residents of Hinton were beginning to accept the woman physician, Bessie was presented with a medical case that challenged the confidence in her abilities and threatened to undo the progress she'd made with the townspeople. An itinerant worker had been thrown from the buggy he was driving, and his spooked horse dragged him several feet before stopping. The man had been drinking at the saloon before the incident occurred and, in his drunken state, could not explain the extent of his injuries when friends carried him to Bessie's office.[25]

After a thorough examination, Dr. Bessie determined he was suffering with a double fracture in his jaw, and he'd sustained multiple cuts and severe bruises. Treating the cuts and bruises was easy, but how to handle the jaw required deep thought. She couldn't cast or splint the break, and a bandage wasn't sufficient to hold the bones in place after she reset them. She decided the best course of action was to remove one of the man's molars, which would provide a space for a feeding tube to be inserted. Once that was done, she brought the edges of the bones together, then wound the upper and lower teeth together and tightened it in a way that

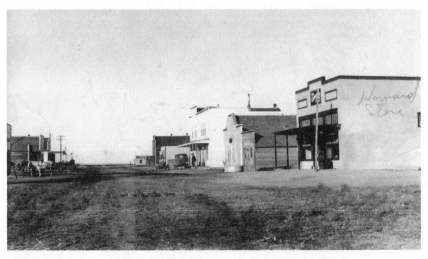

Carpenter, Wyoming, was the location of Dr. Bessie's doctor's office in the West. Cities and Towns, Carpenter P2006-45/1, Wyoming State Archives.

would keep the jaw firmly in place. She finished off the procedure with a sturdy bandage around the chin, jaw, and head.[26]

Weeks passed before Dr. Bessie could determine if the treatment worked. "When [the] day came, I was overjoyed to see the result," she recalled later in her journal. "The experiment had been successful. The bones had healed, the jaw was firm, the teeth were in perfect alignment, and there was not the slightest indication of a facial deformity."[27]

After her first year in practice, Dr. Bessie was a respected member of the community. Her practice was thriving, and the money she made allowed her to live modestly but comfortably. She was able to pay back the loan she'd taken out to set up her office and even considered the possibility of purchasing a fluoroscope (X-ray machine) in time. Nothing could have prepared her for the life change to come. Within a few months, she lost her beloved brother and sister-in-law. Nellie Efner died of an infection a day after giving birth to her fifth child. William was killed in a tragic accident three months later.[28]

At first, Nellie and William's children were separated and sent to live with various friends and relatives. Bessie was brokenhearted the siblings

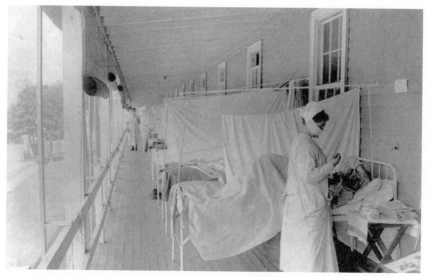

A nurse tends to a patient at a San Francisco Hospital during the flu pandemic of 1918. Courtesy of Library of Congress (in public domain).

could not stay together, because they had lost so much in a short amount of time. She entertained the idea of taking in the three little girls but knew it would be a struggle because she barely made enough to keep herself afloat. Bessie had also met a man in Hinton with whom she'd fallen in love, and the two planned to be married. She wasn't certain he'd be as inclined to take her as his wife if three children were a part of the equation. She had plans to discuss the situation with him when she returned to town after her brother's funeral in Pierson, but her betrothed suddenly passed away.[29] The string of tragedies overwhelmed Bessie. Crushed and defeated, she traveled back to Hinton.[30]

It was difficult for Bessie to pick up where she left off before the heartbreaking events had occurred. She thought about leaving and starting over again. She reasoned she would be so busy in a new location that the memory of her deceased loved ones might lessen. A surprise visit from her father helped her decide what she should do. He had come not only to see how she was doing but also to let her know of another town in need of a doctor. A longtime physician in the town of Moville, eighteen miles east of Sioux City, was retiring, and Bessie's father felt she was the perfect one to take his place. He also felt opportunities for advancement would be greater for his daughter there. Moville was larger than Hinton.[31]

Bessie wasted no time relocating to Moville. She found a suitable site for her office and home. The change did indeed do her good. She focused on being a good doctor and learning more about medicine through hands-on experience. The local newspaper printed an article announcing that Dr. Bessie had arrived and introduced readers to her background and previous experience. Her practice became a busy one, with the bulk of her new patients being obstetric cases. In many instances, at least in Moville, it appeared women preferred to see a female physician. In time Bessie's sadness began to slowly subside. Thoughts of her nieces and of the dying words of her sister-in-law to her to "not let my children come to want" only intensified, however.[32] Bessie decided she had to bring the girls to her home to live. Her father and other relatives tried to convince her she was taking on more than she could know, but she believed it was for the best.[33]

"I . . . fully realized that with the three children depending upon me I could never expect to look forward to an acceptable marriage or a home and family of my own, something that every woman looks forward to as the final and full realization of her own womanhood," Bess recalled in her memoirs. "I considered all that and lost much sleep over it, but I always came back to the same conclusion: I have no choice. I cannot do otherwise. May the consequences be for me what they will, God will help me."[34]

More than a few adjustments had to be made to accommodate Bessie's nieces. She had to make room for them in the living quarters above her office, get them to school, and find someone who could stay with the girls when she had to be gone several days on various house calls. The monumental task provided Bessie with a renewed sense of purpose and motivation to carry on. She was perpetual motion. Her homelife was a blur of activity, and her practice was flourishing. A year after she opened her office in Moville, she'd earned enough money to purchase her own home. The house she selected was large enough for herself, her nieces, and her ever-expanding business.[35]

Dr. Bessie had a reputation for responding quickly to calls for medical help, braving the harshest elements to get to patients in need, and being discreet. There was one occasion, however, where she was forced to be less close-lipped about a case. She was called to a farm ten miles out of town to respond to a woman who was about to give birth to her twelfth child. The delivery of the baby was successful, and the doctor returned home once it was clear mother and infant were doing well. Two days later, Bessie received a call to hurry back to the farm. The mother had become ill.[36]

Bessie examined the patient, who was suffering with abdominal pain and running an elevated temperature. She believed the woman could be suffering with a virulent infection. She took a sample from the mother's pelvic region and sent it to a laboratory in Sioux City for testing. The results showed that the woman had gonorrhea. Her husband had been unfaithful to her with prostitutes and had infected his wife in the last stage of her pregnancy. It was all the doctor could do to hold her tongue when relaying the woman's condition to the husband. She didn't say

anything about the nature of the infection but did express the seriousness of his wife's condition.[37]

Instead of expressing his gratitude for the diagnosis and proper treatment his wife could now be given, he went into a rage. He cursed Dr. Bessie and accused her of neglecting the mother of his children. He told her he was not going to pay her and threatened to sue her for malpractice. He then rode into town and told all who would listen that Bessie was responsible for his wife's poor health.[38]

Dr. Bessie sought legal advice. She wanted the vile rumors to cease and knew of no other way to ensure her reputation be kept intact. Years later, she recalled,

> I called my attorney, told him of the case, also explained the evidence that I had, and instructed him to institute legal action against this man and to bring him to court, where I could present my evidence and expose him publicly for his contemptible behavior, unless he would immediately stop spreading this rumor, but rather pay his bill in full by the next morning. My attorney did as I had instructed him and served notice on him, informing him of the evidence I had. The result was that by the next morning I had my pay in full, and the slanders he had been spreading stopped from that time on.[39]

Bessie and her family lived happy lives in Moville for more than two years. With rare exceptions, they liked the people in town, and residents liked and respected Dr. Bessie and her girls. It seemed they were destined to continue thriving in the charming Iowa community, but the bank panic of 1907 brought a halt to the dream of living happily ever after in Moville. The financial crisis was set off by a series of bad banking decisions and a frenzy of withdrawals caused by public distrust in the banking system. According to Bessie's memoirs, "the panic did not last very long, but was disastrous while it lasted, and brought to an abrupt end the universal prosperity the country had enjoyed for the past ten years. Several railroads went into receivership, thirteen New York banks went into bankruptcy, affecting thousands of banks throughout the country. A serious unemployment situation and a drastic cut in wages followed. People had no money and could not borrow any. Farmers couldn't sell

or buy, the banks refused to release any money, and the whole country became panicky."[40]

As a result, Bessie's funds quickly depleted. She had expenses of her own to pay and no money coming in. Her patients couldn't pay their doctor's bills, and no new patients were coming into her office, because most of the people in the area considered her services a luxury they could do without. As a result, Bessie struggled to make ends meet. She managed to keep food on the table but couldn't afford to pay the mortgage on her home and business. Since she had acquired the loan to construct her house and office, she'd never missed a payment. She explained her circumstances to the lender, but they were unsympathetic. The lender started foreclosure procedures, and Bessie and her girls were forced out. Another doctor, a young man who had grown up in Moville and who had recently graduated from medical school, moved into Dr. Bessie's home and office. He took over the space with his new wife, a woman who happened to be the daughter of the town's most wealthy citizen.[41]

Humiliated and financially destitute, Bessie contemplated her options. She felt she had no one to turn to, not even her father. He had been one of those who had warned her against taking in the children. All she believed was left for her to do was pray. An answer to her prayers came in the form of an elderly man the townspeople called Uncle Ira. Ira was moved by what had happened to Bessie and offered to help. He offered to loan the doctor one hundred dollars. He hoped it would be enough to get her through the setback. She gratefully accepted.[42]

The doctor used the funds to settle her affairs and purchase train fare west for herself and her family. They would make a new life for themselves in Wyoming.[43]

Bessie's home in Carpenter, Wyoming, was a simple one-and-a-half-story house with three rooms downstairs and one upstairs. One of the downstairs rooms would serve as the doctor's office and another as an examination room and a place where patients needing extra care could stay overnight.[44]

The cost to move, equip the home and office with necessities, and purchase a small amount of food was more than Bessie anticipated. She had exactly seventy-five cents to her name, and Christmas was close at

hand. Since Carpenter wasn't yet a bustling town, Bessie suspected it would take a while to build her practice. She had no one to inform the community her office was open for business. There were no phones or newspapers, nor was there a school, church, or post office—only ranches scattered miles apart throughout the prairie.[45]

Ranch hands were the first to come to her door in need of a doctor. Unfortunately for Bessie, they weren't needing help for a human being but a horse. "I have very urgent case," the panic-stricken man announced when she answered his persistent knock on her office door. "One of my horses is very sick, and I might lose him if I am not able to get him immediate help. I have only one team, and if I lose this horse I am ruined."[46] Bessie explained to the man that she wasn't a horse doctor but a doctor for people and that she didn't know anything about treating animals. The rancher insisted that if she could treat a man, she could treat a horse. As he was describing the sick animal's symptoms, it occurred to her the horse might be suffering from colic. The details of the ailment sounded the same as a human being suffering from the malady. He pleaded with her for a remedy. She told him she could prescribe some medicine and informed the rancher he'd have to increase the dosage to be four times stronger than what a man would be given. Dr. Bessie told the owner of the horse that she'd only let him have the medicine if he absolved her of any responsibility. He assured her he would assume all the risk. She reluctantly agreed, and he hurried off with the medication. She charged the rancher, her first patient in Wyoming, seventy-five cents for the services.[47]

The rancher returned to Dr. Bessie's office the following day with news that the horse made a full recovery. He was grateful for her help and told everyone in the area that she was an amazing doctor and boasted that if she could cure a horse, she would be able to work wonders for sick people.[48]

Below-freezing temperatures, prairie fires, and violent hailstorms were just a few disagreeable conditions Bessie and her family endured during their first year in Carpenter. The doctor and her girls grew close as they weathered the elements. Bessie was thankful for their time together, but the downside was the lack of patients. Even with the positive word of

mouth from the rancher with the now-healthy horse, people didn't venture out in the bitter cold or when their livelihood was threatened with incineration. With no patients, there was no money coming in. Bessie and the girls sustained themselves on what little food the doctor grew herself or could afford to buy. The diet consisted of potatoes, pork and beans, turnips, and prunes. It took two years of hard living before Doctor Bessie's practice reached the same level of success she'd had in Moville.[49]

Dr. Bessie's services comprised a territory of about thirty miles. She was the only doctor between Cheyenne and the Nebraska State line to the east. To the south her practice extended into Colorado, and to the northwest, she served people beyond Burns and the Union Pacific Railroad to the border of the open grazing land in the northern part of Laramie County. More than once was Bessie caught in the middle of a rainstorm either going on a house call or returning home. She credited her faithful horse for safely getting her from one patient to another and home again. There were times when Bessie needed another form of transportation to get her to sick or injured people in need of her help. Such was the case one late evening in the fall of 1909.[50]

A loud pounding on the doctor's office door rousted her out of bed. She was half asleep when she cautiously answered the door. Two grim-faced Hispanic gentlemen, who barely spoke English, greeted Bessie and quickly handed her a note. The note explained that the men were employees of the railroad who were living in a small town in Colorado with their families. One of the section worker's wives had written the note requesting Bessie come quickly because she was having a baby and needed help. The men had traveled to the doctor's office by handcar and would use the same mode of transportation to take her to the expectant mother. Bessie quickly dressed and grabbed her medicine case, and the three hurried on their way. The railroad tracks were three city blocks from the doctor's office. By gesture and using a few words in English, the men let Dr. Bessie know to climb onboard the handcar and take a seat.[51]

"It was a crisp fall night; overhead was a beautiful starry heaven, and a waning moon was approaching the western horizon," Bessie wrote later in her memoirs.

As I was traveling along on this unusual conveyance at a pace much faster than the average horse would travel, trying to beat the stork in this race, I began to feel quite at ease and rather enjoyed this experience, which was most unusual even here in this new, wild, and woolly country, where almost anything could happen.

When we arrived at the designated town, my Mexican companions escorted me to the house from which the call had come, bowed courteously, said something in their language which I did not understand but presumed that it meant good night or goodbye, and then I in turn thanked them for the courteous service they had rendered me, and thereupon they turned and disappeared into the darkness.

The husband and the wife who had called me were happy and grateful that I had arrived and that I had succeeded in beating the stork in this race. In about an hour or so I delivered a healthy baby. When mother and child were cared for and comfortable again, I managed to get a few hours' rest myself and then returned home the next morning on the mixed train that made a daily run between points in Colorado and Cheyenne.[52]

Dr. Bessie's career as a physician in the rugged West was trying but, ultimately, richly rewarding. She learned how to make do with limited equipment, diagnosing broken or fractured bones by touch because she didn't have an X-ray machine. Her nieces acted as her nurses when needed, helping to assist her in minor surgeries and even with tooth extractions. When medical supplies such as bandages or crutches were lacking, she used strips of bedsheets and wooden boards cut to fit for her patients. She carried her own stock of standard drugs and filled her own prescriptions.[53]

Bessie later noted in her memoirs,

As I now look back on those years of my practice on the frontier and recall to my mind the physical hardships, the professional handicaps, the hazardous drives, the long and tedious vigils in the crowded homesteaders' shacks and the meager financial rewards I received, I wonder now how I had the courage to go on.

But I survived, and so did my patients despite all these hardships and disadvantages. All of which proves again that man by nature is a pretty tough creature.[54]

Bessie was the first female doctor in Carpenter and also the town's first postmistress. She received her commission on March 31, 1908.[55]

In the summer of 1909, Dr. Bessie traveled to the town of Burns, thirteen miles north of Carpenter, to help deliver a baby. After the child was born, she stopped to have dinner at a local hotel, and it was there she met a Lutheran minister who would one day become her husband. Ironically, shortly after their first meeting, Reverend Alfred M. Rehwinkel became Bessie's patient. The minister's leg had been cut on a wire fence, and he needed stitches. The couple courted for more than a year before becoming engaged. Bessie and Alfred were married in Cheyenne, Wyoming, on September 28, 1912. Shortly after they were wed, the couple moved to Western Canada, where Alfred was hired to lead a parish in a place called Pincher Creek. Bessie's nieces Elsie and Ina were then old enough to be on their own. Elsie was attending nurse's training school in a hospital in Cheyenne, and Ina was in college in the same city, studying to become a teacher. Reta accompanied her aunt and Reverend Rehwinkel to their new home.[56]

While in Canada, the Rehwinkels had three children of their own, a son and two daughters. Bessie and Alfred were married for fifty plus years.[57]

Dr. Bessie Efner Rehwinkel died on May 26, 1962, of cerebral thrombosis. She was eighty-nine years old.[58]

A Flu Treatment

A medical report prepared by the staff at the American Nurses Association (ANA) in 1918 outlining the proper way to treat influenza was circulated throughout the West during the pandemic. According to the ANA, the treatment offered in the circular was the most successful method of dealing with the flu and was being employed successfully by physicians from coast to coast. More than three hundred cases without a death were treated as follows:

Orange Juice: Cut an orange in half and extract the juice, mix this juice with a glass of cold water, and drink. Repeat every two or three hours.

Internal Bath: Take a quart of warm water; add a teaspoonful of salt; allow it to dissolve; then use it as an enema. If chills begin, take an enema morning, noon, and night, and once a day thereafter.

Capsicum is ordinary red pepper. Take one grain every two hours during the chill stage.

Hot Foot Bath: During the early stage, the patient sat on the bed well covered with blankets and the feet soaked in hot mustard water for five minutes at a time, several times a day.

For Acidity: In some cases, the condition of the system was found to be very acidic. In these cases, one-half a teaspoonful of Bicarbonate of Soda (plain baking soda) was added to four (4) ounces of water, this used as an enema but was retained instead of passed off.

Pain: In case there was severe pain, especially over the back, hot compresses were used if the patient lived in the country. If in the city, cloths were wrung out of hot water, placed over the cloths, and kept on until relief was obtained, then sponged with cool water and covered well with blankets. (Very hot water bottle may be used in place of electric pad.)

Abnormal Temperature: When the temperature reached 103 or more, a tepid bath, followed by a rub, was given.

Pneumonia: The great fear of all has been pneumonia; yet, where this very simple treatment was followed there was not a single death.

Chop or grate onions very fine, mix with less than an equal part of rye flour, and make into a poultice. Apply over the chest in form of a poultice and over this an electric pad. A simple treatment but wholly efficient.

Cough: In cases where the system is sub-acidic, a mixture of equal parts of lemon juice and honey, well mixed. A teaspoonful every hour or two proves successful.

When the system is super-acid, equal parts of orange juice and honey well mixed. A teaspoonful every hour or two will bring similar results.

Diet: With the very first symptoms of the disease, all solid foods should be absolutely prohibited and the diet limited to fruit juices, and nothing but fruit juices.

As the temperature lowers, broths may be given, and these may be of meat, oatmeal, wheat, whole rice, etc., but no solid food until the system has reached a normal temperature, then the patient may be gradually started with semi-solid food.

This above may be termed a drugless treatment, but it is certainly a safe, sane, and sensible one. Moreover, it is one through which not a single patient has been lost.[59]

Bethenia Owens-Adair

Northwest Physician

*I am determined to get at least a common education. I now know that
I can support and educate myself and my boy, and I am resolved to do
it; furthermore, I do not intend to do it over a washtub either.*

DR. BETHENIA OWENS, 1874

A LOUD RAP ON THE DOOR OF THE HAT SHOP COAXED THE DIMINUTIVE
young woman from her work of loading bolts of fabric into a trunk.
The scruffy messenger on the other side of the door smiled politely
when Bethenia Owens greeted him and then handed her a letter. The
monogram on the envelope showed that the correspondence came from
Dr. Palmer, a prominent physician in the northwestern area of the United
States.[1]

The messenger waited patiently for Bethenia to break the seal on the
envelope and read the enclosed note. "How sad," she said to no one in
particular. "One of our elder citizens passed away . . . and six local phy-
sicians who treated him at one time or another want to do an autopsy.
And as one of the newest doctors in town, I'm invited to attend the
operation."[2] The messenger grinned and nodded, anticipating a negative
response.

Bethenia knew the invitation was meant as a joke and was deter-
mined to turn the tables on the pranksters. There were very few women
in medicine in 1872, and, by and large, they were not well received by
men in the same profession.[3]

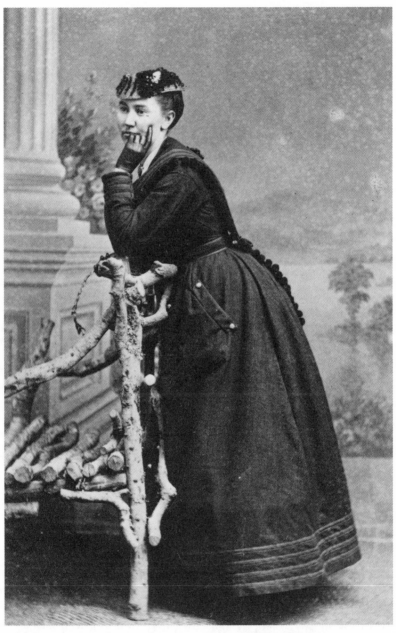

Dr. Bethenia Owens-Adair. Courtesy of the Oregon Historical Society (photo in public domain).

Bethenia studied the note, carefully considering the proper response. "Give Dr. Palmer and the others my regards," she announced, "and tell them I'll be there in a few minutes."[4] A stunned look fell over the courier's face as he turned and hurried off down the dusty thoroughfare in Roseburg, Oregon.[5]

Bethenia followed a safe distance behind the messenger to Dr. Palmer's office, where she waited outside. She listened in as the courier relayed the information she had given him and heard the doctors laughing heartily. Bethenia opened the door, momentarily interrupting the merriment. One of the doctors regained his composure and walked toward her with his hand outstretched. She shook it, and the physician choked back a giggle.[6]

"Do you know the autopsy is on the genital organs?" he snickered. "No," Bethenia replied, "but one part of the human body should be as sacred to the physician as another."[7] The mood in the room quickly changed to one of disbelief and then, in an instant, to indignation.

Dr. Palmer objected to Bethenia's presence during the procedure and insisted that he would leave if she stayed. Bethenia was unmoved by the pronouncement and stood her ground. "I came here by written invitation," she calmly confessed, "and I will leave it to a vote whether I go or stay; but first, I would like to ask Dr. Palmer what is the difference between the attendance of a woman at a male autopsy, and the attendance of a man at a female autopsy?"[8]

For a few moments none of the male physicians replied. She had presented to them a sensible query, demonstrating her dedication to the profession and a maturity they had underestimated. One by one, the men slowly voted in favor of Bethenia staying and performing the procedure as well.[9]

News of Bethenia's brave stand circulated throughout the lumber town. A number of curious onlookers, including the messenger, lined the street to get a look at the strange female doctor as she exited the office. Many citizens strongly disapproved of a woman in that line of work, and had it not been for her family members, the scene would have likely erupted into violence.[10]

Not long after the much-talked-about event, Bethenia completed the tasks of closing her milliner business, moving to northern Oregon with her sister, and starting her own medical practice. Physicians, male or female, were woefully lacking in many parts of the West. Dr. Owens hoped the need for her skills in Portland would far outweigh any reservations people might have had regarding her gender.[11]

From an early age, Bethenia exercised her individuality and proved herself a pioneer in many circumstances. She was born in Missouri on February 7, 1840. Her father, mother, and eight siblings moved to Oregon in 1843 and settled in Clatsop County.[12] By the time she turned eighteen, she had been married, divorced, and had a son. She supported herself and her child by taking in laundry, work suitable for women but objectionable to Bethenia's father, who offered to take care of his daughter and his grandson. Bethenia steadfastly refused such monetary help from her family but did accept the sewing machine her parents gave her. After teaching herself to be a seamstress, she added mending to her list of services for hire.[13]

Bethenia's formal education was limited. At the age of sixteen, she could barely read and write. Anxious to learn and better herself, she leapt at an offer from a good friend in nearby Oysterville, Washington, to attend school there. Bethenia worked her way through primary school by doing laundry for ranch hands. Through books and lessons, she overcame the hardships associated with a failed marriage and single parenthood.[14]

An urgent plea from Bethenia's sister persuaded her to leave Washington and return to Clatsop County. Bethenia agreed to help her ailing sister in exchange for the chance to attend and teach school in Astoria. After arriving back in Oregon, Bethenia immediately went to work soliciting students for a summer school term. Her dauntless will and determination are evident in Bethenia's recollection of the experience.[15] She wrote in her memoirs,

> I succeeded in getting the promise of sixteen pupils, for which I was to receive $2 for three months. This was my first attempt to instruct others. I taught my school in the Old Presbyterian Church, the first Presbyterian Church building ever erected in Oregon.

Of my sixteen pupils, there were three who were more advanced
than myself, but I took their books home with me nights, and, with the
help of my brother-in-law, I managed to prepare the lessons before-
hand, and they never suspected my incompetency.[16]

In the fall of 1861, Bethenia again enrolled in school. The principal
of the institution assisted her with her work when needed. She awoke at
four o'clock every morning to study, determined to take full advantage of
the "great opportunity" she had been given. Within nine months Bethe-
nia had completed her high school education. Before and after attending
classes, she kept up with her variety of labor-intensive jobs and gave
special attention to her son, George.[17]

Bethenia's thirst for knowledge did not subside after graduation. Her
fondness for nursing and caring for sick friends and family sparked in her
a desire to study medicine. Her superior talent in hat design and dress-
making helped her raise the necessary funds to attend medical school.
She became deeply committed to the calling after witnessing an elderly
doctor's inability to properly care for a small child.[18]

"The old physician in my presence attempted to use an instrument
for the relief of the little sufferer, and, in his long, bungling, and unsuc-
cessful attempt he severely lacerated the tender flesh of the poor little
girl," she recalled years later. "At last, he laid down the instrument to
wipe his glasses. I picked it up, saying, 'Let me try, Doctor,' and passed
it instantly, with perfect ease, bringing immediate relief to the tortured
child."[19]

That momentous event set in motion the course of Bethenia's new
profession.

Words of encouragement for Bethenia's goal were few and far
between, however. In fact, once she'd made her career plans known,
only two people supported her. One was a trusted physician who loaned
her his medical books; the other was a judge who applauded her ambi-
tion and assured her that she "would win."[20] Most of Bethenia's family
and friends were opposed to her becoming a doctor. They sneered and
laughed and told her it was a disgrace for a woman to enter such work.

Bethenia disregarded their warnings and criticism and pressed on toward her objective.[21]

Bethenia began her studies at the Philadelphia Eclectic School of Medicine in 1870. Students at the college learned ways to treat the sick using herbs, mineral baths, and natural medicines.[22] After a two-year absence from her home and son, who was with her parents, Bethenia returned to Roseburg, eager to set up a practice. The controversy that had surrounded her after the autopsy incident, however, forced her to open an office in Portland instead. The ground floor of her Portland facilities had two rooms that she fitted for eclectic and medical baths. Several patients sought out her unorthodox method of dealing with sickness and pain, and in no time, her business was making a profit. Bethenia could then afford to send nineteen-year-old George to the UC Berkeley Medical School. He graduated in 1874.[23]

Although Dr. Owens's eclectic medical practice was prosperous, she was not satisfied. She pined for more knowledge in her chosen field. On September 1, 1878, she left Portland for Philadelphia to seek counsel from a professor at her former college. She was advised to attend the University of Michigan, and she left at once to enroll. "Arriving there, I was soon settled, and in my seat for the opening lecture," she later recorded in her journal. "During the ensuing nine months, I averaged sixteen hours a day in attending lectures, in hard study, and in all exercise required in the courses, after which I put in ten hours a day (excepting Sundays) in study during the vacation."[24]

Her daily schedule was filled with lectures, clinics, laboratory work, and examinations. Bethenia was so engrossed in her studies that she did not hear the bell ring between classes. She never tired of the learning process, and she never suffered with a day of sickness.[25]

In June 1880 Dr. Owens received her second degree. After graduation she traveled with one of her classmates to do fieldwork in hospitals and clinics in Chicago.[26] In the fall of that same year, she returned to the University of Michigan, accompanied by her son. Together, the mother and son doctors attended advanced lectures on obstetrics and homeopathic remedies. Six months after their arrival, they embarked on a trip abroad. Their European tour included visits to Hamburg, Munich, Paris,

and England. It was a welcomed change of pace for Bethenia, who, by then, had been continually working and studying for more than thirty years.[27]

Dr. Owens settled in San Francisco after her journey across the sea, and it was there she met her second husband. Before she met Colonel John Adair, Bethenia maintained that she was fully committed to her profession and not interested in marriage. A brief courtship with the handsome Civil War veteran changed her mind. The two were married on July 24, 1884, in Portland, Oregon. Three years after the wedding, the Adairs were expecting their first child. Bethenia boasted in her journal that she was happier than she had ever been before. Her elation wouldn't last long.[28]

"At the age of forty-seven I gave birth to a little daughter," she wrote, "and now my joy knew no limit—my cup of bliss was full to overflowing. A son I had, and a daughter was what I most desired . . . For three days only, was she left with us, and then my treasure was taken from me, to join the immortal hosts beyond all earthly pain and sorrow."[29]

Bethenia found solace from the grief of her daughter's death in caring for the sick in her Portland practice. No matter what the weather conditions were and knowing that there was no other doctor within a two-hundred-mile range, she never refused a call from a patient. She attended to all those in need, at times traveling through dense undergrowth and swollen rivers.[30]

Never content with being solely a physician, Bethenia became a student again in 1889 and enrolled in a Chicago medical school, seeking a postgraduate degree.[31] After she completed her studies, she returned home to her husband and the teenage son they had adopted.[32] Her practice continued to grow, and before long, she found she could not keep up with her professional work and maintain a home for her family. She chose the practice over her marriage and sent her son John away to a farm they owned in Astoria. The Adairs' marriage ended in 1903.[33]

At the age of sixty-five, Bethenia retired from her practice. Her focus then shifted from day-to-day medical treatment to research.[34] She studied such controversial topics as the sterilization of the criminally insane. Bethenia's analysis led her to believe that insanity and criminal actions

were hereditary. Her famous work on the subject, entitled "Human Sterilization: Its Social and Legislative Aspects," was published in 1922 and brought her instant recognition in the field. Three years after Bethenia presented her findings, a sterilization statue was adopted as state law in Oregon.[35]

In addition to her medical research, Bethenia worked hard as a lobbyist for the Woman's Christian Temperance Union. She remained a staunch social and political activist until 1926, when she died of natural causes at the age of eighty-six.[36]

An Excerpt from Dr. Bethenia Owens-Adair's Paper Titled "Human Sterilization"

In submitting this little publication to the public, it is with the desire, the hope and belief, that the ever watchful eye of our great commonwealth, will appreciate the immence [sic] value of this process for preventing disease and crime through propagation. Since 1883 when I said to the physician who was in charge of the Oregon Insane Asylum, that if the time ever came, that I might be permitted, I would then use my pen and my brain along these lines. Since then I have used my tongue many, many times, in season and out of season, and I have received in return many rebukes and much good advice, as to modesty, being a priceless gem which every woman should wear. But not until 1904 did the first opportunity come, when I could use my pen and I assure you I lost no time in sending off the following communication to the Oregonian, and my delight at seeing it in print was beyond expression, to say that this publication shocked my family and many of my friends would be putting it mildly, I am older now and my tears do not lie so shallow (as mother said) as in my childhood days, and there is something in getting used to unpleasant things and yet, I am not innured [sic], but I can go right on smiling just the same.

To illustrate the trend of thought, only 7 years ago when I wrote my first communication to the Oregonian I received four letters all eulogizing and congratulating me on my bravery, etc., but the interesting part was, that those letters were all nameless, who would think of addressing me to-day on this subject without signing his or her name; not one, no not one. The world is being educated along these lines and is seeking for the purification and betterment of humanity, which in time will be found and vertified [sic] in the yet unborn children whose parents' blood shall be free from disease and crime. Through this publication I shall try to prove what I have been preaching for 30 years, that the power of transmission from parent to child, is a law which holds good through all life and dates back from the beginning of time, "Like begets like" from which there is no escaping. I shall produce statistics and quote from some of the great thinkers of the age especially from Judge Warren Foster, the Superior

Judge of the highest and greatest criminal court in America. I advise all who can read "Hereditary criminality and its certain cure" by Judge Foster in Pearsons November 1909. He advocetes [*sic*] sterilization as the "certain," and only cure.

My first article on this subject published in the Oregonian was as follows: This is a deep and serious subject, and one far too great to cope with in its entirety, yet I repeat, much can and should be taken. Some of the worst ills to which humanity is heir, such as insanity, epilepsy, and cancer, are almost certainly transmitted by the immediate progenitors. The greatest curse of the race comes through our vicious criminal and insane classes, and to my mind this is the element that should be dealt with, not by chloroform or strangulation, but by the science of surgery, for if their power to reproduce themselves were rendered null a tremendous important step in advance would have been taken, not only without injury to life, but often with positive benefit to the victims themselves.

Over 20 years ago I visited our State Insane Asylum at Salem. My friend Dr. H., then in charge, received me graciously, and conducted me through the various wards. On our way from the wards back to luncheon I said: "Doctor, this is a horrible phase of life; and when is it to end?" "I do not know. It is hard to tell," he replied. "If I had the power," I continued, "I would curtail it, for I would see to it that not one of this class should ever be permitted to curse the world with offspring." He stared at me and finally said: "Would you advocate that method?" "I certainly would, if I were not a woman, and a woman M.D., to whom, I know too well that at this day and age it would simply mean ostracism," I answered. "Well," he rejoined, "I beg you not to mention this subject to my wife, for she would be shocked and horrified." "I shall not mention it to your wife, but I want to tell you right here that if I were in control of this institution, as you are, I would at least give many of these pitiable unfortunates the one chance of recovery, which might restore their reason. You know, doctor, as well as I do that hysteria and insanity are often due to diseased reproductive organs. Think of those loathsome victims of an unnamable vice under your charge. It would be nothing less than common humanity to relieve them of the source of their curse and destruction by a simple surgical method that might give them a chance to recover their reason."

Eight or ten years since, in a conversation with an eminent attorney concerning a mutual friend and near neighbor, whose wife had recently called upon this attorney at dead of night to protect her and her children from her husband, who had for the second time become suddenly insane, he said to me. "This is terrible. But who would have thought of this level-headed businessman going insane?" I responded, "Remember, we

know it is in his blood by family inheritance. And now I am going to say what will shock you, which is that every person admitted into an insane asylum should be so dealt with as to preclude reproduction." Instantly and warmly he exclaimed, "I sanction that, and I will go farther by including every criminal that goes through the penitentiary doors." Thereupon we shook hands on it then and there, feeling sure that the time would come when the commonwealth forced to grapple with this vital subject, would be able to adopt these measures with the full assent of a majority of its citizens.[37]

Lucy Hobbs

Pioneer Dental Heroine

Her place in dental history is secure as the individual who conquered prejudice and precedent and prepared the way for women to become practitioners of the science and art of dentistry.

<div align="right">

DR. RALPH EDWARDS'S TRIBUTE TO
DR. LUCY HOBBS TAYLOR, 1955

</div>

A STEADY PARADE OF DISTINGUISHED, WELL-DRESSED MEN AND WOMEN marched into a massive community center and joined the crowd already in the building and making their ways from one elaborate exhibit to another. The attendance at the annual Ohio Mechanics' Institute Fair in Cincinnati on September 19, 1860, was overwhelming. A small orchestra serenaded visitors as they wandered about, examining displays of the various inventions and machinery that had received patents. Creators shared details of their devices with patrons and explained how the items would be of benefit. One of the presentations on dental mechanics, sponsored by Drs. Wardle and Doughty, featured an array of false teeth made by the dentists and one of their apprentices.[1]

Several curious individuals inspected the objects, paying close attention to a set of teeth with a small placard sitting in front of it marked "Lot #45."[2] Next to the placard was a silver medal and a note from a fair judge that read as follows: "Although inferior to its competitors [the] item was the work of a student [and is] worthy of a high degree of commendation."[3] Given the attitude society had about women in the medical

Dr. Lucy Hobbs. Kansas State Historical Society.

profession at that time, the judges might not have been as complimentary if they'd known the teeth were made by Lucy Hobbs.[4]

Lucy Hobbs's journey from the Ohio Mechanics' Institute Fair forward to eventually making history was a long, arduous one. Born in Franklin County, New York, on March 14, 1833, she was one of eleven children. Her mother died when Lucy was ten years old. Her father Benjamin remarried, but his second wife passed away shortly after their wedding. Unable to raise his children and hold down a job, Benjamin sent the youngsters to his friends and family to care for them. Lucy was sent to a residential school in New York called Franklin Academy. She was an exceptional student and graduated in the top of her class in 1849 at the age of sixteen.[5]

Lucy embarked on a teaching career after leaving Franklin Academy and took a job at a school in Brooklyn, Michigan. Teaching was not the occupation she preferred, however. She wanted to be a doctor. Society frowned on women studying medicine. Male doctors, hoping to prevent the "fairer sex" from entering the field, publicly chastised women who had such desires. They often referred to them as unnatural and lacking in the ability to know their place. A protest resolution drafted by male students at Harvard University in 1850 summed up the position of many men on the subject.[6]

> Resolved, That no woman of true delicacy would be willing in the presence of men to listen to the discussion of the subjects that necessarily come under the consideration of the student of medicine.
>
> Resolved, That we object to having the company of any female forced upon us, who is disposed to unsex herself, and to sacrifice her modesty by appearing with men in the medical lecture room.[7]

An article in an 1867 New York medical journal boldly announced that many male physicians in the East "hope to never see a day when the female character shall be so completely unsexed, as to fit it for the disgusting duties which imperatively devolve upon one who would attain proficiency, or even respectability in the healing art."[8]

Lucy met a physician in Brooklyn who didn't believe women should be excluded from pursuing careers in medicine. She persuaded him to teach her physiology and anatomy. During that time she learned of a medical school in the country that would accept women and decided to apply. Lucy applied to the Eclectic College of Medicine in Cincinnati, Ohio. In anticipation of being accepted, she packed her things and moved. When she arrived in Cincinnati, she was informed the school had decided to change its policy about allowing women to attend. Crestfallen, she sat outside the school entrance to contemplate what to do next. Charles A. Cleaveland, professor of materia medica, therapeutics, and medical history at the college, saw her and offered a solution. He had reviewed her application and the letters of endorsement that accompanied it and was impressed. He agreed to give her private lessons in all the areas of medicine, including pharmaceutical and the treatment of disease, which was his specialty. He suggested she change her field of interest to dentistry. He explained the profession was much more welcoming of women and that "a dentist need not make calls away from his office in all kinds of weather."[9] It didn't take long for Lucy to consider the idea and agree with the professor's reasoning.

Prior to the establishment of the Baltimore College of Dental Surgery in 1840, most people believed training in that area wasn't necessary. West of the Mississippi, the job of pulling teeth was relegated to a barber or a blacksmith. Pioneers traveling across the frontier by wagon train were convinced gargling with their own urine the first thing in the morning preserved the life of the teeth. Between so-called granny remedies and the idea that healthy teeth and gums weren't essential, it was difficult for most to accept the value of a dentist. Trained doctors were slow to recognize the importance of a dentist and treated the profession with contempt. Lucy knew the lack of respect dentists received, and she looked forward to helping change potential patients' minds.[10]

The education Lucy received from Professor Cleaveland was important, but if she was to become a dentist, she needed to study with a dentist. She visited several dental practices in the area, asking the doctors there for an opportunity to learn the trade under their instruction. It wasn't until she visited Dr. Jonathan Taft, dean of the Ohio College of Dental

Surgery, that her request was granted. Dr. Taft agreed to train her for a three-month period. At the end of those three months, Lucy set out to find a doctor who would accept her as his apprentice. Dr. Samuel Wardle kindly welcomed her to his practice. Lucy later recalled how hopeful she was after talking with Dr. Wardle. She wrote in her memoirs,

> Suddenly, there appeared in the western horizon a cloud, not as big as a man's hand, for it was the hand of a young girl, risen in appeal to man . . . For the opportunity to enter a profession where she could earn her bread, not alone by the sweat of her brow, but by the use of her brain also. The cloud though small was portentous. It struck terror into the hearts of the community, especially the male portion of it. All innovations cause commotion. This was no exception. People were amazed when they learned that a young girl had so far forgotten her womanhood as to want to study dentistry.[11]

Dr. Wardle taught Lucy all the steps of mechanical and operative dentistry. She learned to pull teeth and to fashion false teeth from rocks. In addition to continued education in anatomy and physiology, she studied the biological sciences, hygiene, and anesthesia. Her apprentice position wasn't a paid position. Lucy earned her living working in the evenings as a seamstress.[12]

In March 1861 Lucy applied to the Ohio College of Dental Surgery and was promptly rejected for the same reason she was turned away from medical school—she was a woman.[13]

At the urging of Dr. Wardle, Lucy temporarily abandoned the thought of getting a dental degree and opened her own dental office in Cincinnati. The nation was on the brink of the Civil War, and unrest in the city prompted her to close the business within the first week. She decided to travel west to the town of Bellevue, Iowa. Hundreds of men were leaving the area to fight for the Union, but those who remained for one reason or another had no problem seeing a woman dentist or having their wives, mothers, sisters, and children use her services when needed. Lucy's practice was a success.[14]

After a year in Bellevue, having gained the experience in the profession she craved and having saved one hundred dollars, Lucy moved

to McGregor, Iowa, where she hoped her practice would do even better. Her dental practice thrived in the new location. By the end of 1862, she'd made a profit of more than $2,500 and was kindly referred to as the "woman who pulled teeth."[15]

Lucy's reputation as a caring and qualified dentist reached every part of the state. One of the people who had heard of McGregor's lady dentist was Dr. Luman Church Ingersoll, president of the Iowa State Dental Society. He invited her to attend their annual convention scheduled to be held in July 1865. Lucy was apprehensive at first. The opposition she'd experienced from the bulk of the men in the profession led her to imagine the worst. Ultimately, she agreed to travel to Dubuque and meet with Dr. Ingersoll and the other attendees. At the very least, she thought she might be able to encourage them to recognize the fact that women were capable of doing the work of a dentist.[16]

Much to her surprise, her fellow dentists were welcoming and inquisitive about her background. During their regular meeting, they elected Lucy as a member of the society. Among those present who had approved such an action was one of her mentors, Dr. Jonathan Taft. Dr. Ingersoll proposed a resolution in support of the position taken by the Iowa State Dental Society in accepting a woman dentist to its membership:[17]

Whereas, The Iowa State Dental Society has, without a precedent, elected to membership a lady practitioner of dentistry, and

Whereas, It is due to her to know that the unanimous vote by which she was elected was not simply a formal vote, and

Whereas, It is due to the profession at large, that we make a formal declaration concerning the position we have assumed in our action, therefore

Resolved, That we most cordially welcome Miss Lucy B. Hobbs, of McGregor, to our number, and to our professional pursuits, trials, aims and successes.

. . . Resolved, that the profession of dentistry, involving, as it does, the vital interest of humanity, in the relief of human suffering, and the perpetuation of the comforts and enjoyments of life in civilized and refined society, has nothing in its pursuits foreign to the instincts of women, and, on the other hand, presents in almost every applicant for

operations, a subject requiring a kind and benevolent consideration of the most refined and womanly nature.[18]

Lucy was honored and grateful to become a member of the Society. She thanked the men for their kindness. She deemed the reception she had received ample recompense for all the rebuffs and discouragements she had encountered during the past four years while fighting her way into the field and expressed her determination to make her mark in the profession, so that they would never regret the step they had taken.[19]

Convinced more should be done to allow women to enter the field, members of the society prevailed upon Dr. Taft to use his influence at the Ohio College of Dental Surgery to revisit Lucy's application to the school. The doctor agreed. Lucy was accepted and admitted to the institution in November 1865. Because of the years she'd spent being personally trained for the profession by respected dentists and the practical experience on the job that she'd received, she was required to attend only one session. When Lucy received her degree of doctor of dental surgery on February 21, 1866, she became the first woman in the world to earn that distinction.[20]

Professor Jonathan Taft noted about Lucy,

> She was a woman of great energy and perseverance, studious in her habits, modes and unassuming; she had the respect and kind regard of every member of the class and faculty. As an operator she was not surpassed by her associates. Her opinion was asked, and her assistance sought in difficult cases, almost daily by her fellow students. And though the class of which she was a member was one of the largest ever in attendance, it excelled all previous ones in good order and decorum—a condition largely due to the presence of a lady. In the final examination, she was second to none.[21]

Lucy concluded the four-month-long session with exceptional grades and praise for her construction of a set of porcelain false teeth. Her thesis was on dental science.[22]

Shortly after graduating from college, Lucy moved her practice to Chicago. The March 29, 1866, edition of the *Charles City Intelligencer*

included an article about the accomplished doctor's new venture. "Miss
L. B. Hobbs, the celebrated lady dentist, who for several years practiced
dentistry with marked success at McGregor, has removed to Chicago and
opened an office at 93 Washington street where she will be happy to wait
upon her Iowa friends and all others who may desire her professional ser-
vices," the announcement read. "Miss Hobbs graduated at a Cincinnati
college after having taken regular courses of study in anatomy and dental
surgery. We have no doubt she will ere long become the most popular
dentist in Chicago, and we predict for her both fame and fortune."[23]

Dr. Hobbs was elected to the Illinois State Dental Society in May
1866 and, two months later, traveled back to Iowa to speak at the Iowa
State Dental Society conference. In December of the same year, a paper
she had presented to the state dental association was printed in the mag-
azine *Dental Times*. Lucy's paper dealt with the uses of mallet pressure,
rather than hand pressure, in the filling of cavities.[24] Dr. Hobbs wrote,

"The Mallet System" has become the prevailing system among the best
operators. It needs but a few facts to show to every thinking mind, that
it is the best system yet known to the profession for all ordinary fillings,
as very few but can be better and more easily condensed than by hand
pressure. No proof is necessary to show that anyone can do better work,
when he can give all his attention to the placing of the gold in the
cavity, stand easy and natural, and have an assistant do the condensing.

In the old way, the operator was all worn out with a few fillings.
The position was such that in most cases the strength could not be
applied in the right direction, but at a great disadvantage to the opera-
tor, so that after a very few years of practice an operator was worn out
ere he had arrived at any degree of perfection. Anyone that has tried
both systems, will admit that more gold can be condensed in a cavity,
and of course make better filling, as it is more solid, than in any other
way, being driven firmly to place by the mallet, it forms one solid mass.

Let the gold be used in any form you choose. It can be better
condensed with the mallet than with the hand. The human operator
will give it a fair trial. For there are none but are well aware that it
requires strong nerves to endure the hand pressure, without some man-
ifestation of suffering, but with the mallet, I have known the patient to

sleep, when the operation was long, thus showing that it was not very unpleasant.[25]

During her time in Chicago, Lucy met a Civil War veteran named James Myrle Taylor. He worked for the Chicago and North Western Railway in the maintenance shop. The couple were married in 1867, and soon after, James became Lucy's apprentice. In December 1867 the newlyweds moved to Lawrence, Kansas. The city was flush with an infusion of new residents, and dentists were in demand. James transitioned from apprentice to dentist, and the Taylors operated their lucrative practice together. Lucy took the women and children patients, while James dealt with the men.[26]

Both doctors had busy lives outside their work. They were involved in various charitable organizations and active in the state dental society. They lived in a magnificent home with elaborate fountains and lush gardens, where numerous weddings and anniversary celebrations were often held.[27]

Dr. James Taylor passed away on December 14, 1886, after suffering from a long illness. Dr. Lucy Hobbs Taylor continued to see patients but spent the majority of her time with civic activities, including fighting for the cause of women's suffrage.[28]

Lucy suffered a paralytic stroke on August 17, 1910. Friends found her on the floor of one of the rooms of her home, and a doctor was immediately called to the scene. Her recovery was slow, and her entire right side was paralyzed, but physicians believed her condition would improve with time. Sadly, Dr. Taylor never overcame the effects of the stroke and died following a cerebral hemorrhage on October 3, 1910, at the age of seventy-seven.[29]

Historical markers honoring Dr. Lucy Hobbs Taylor have been erected at her place of birth in Franklin County, New York, and in Lawrence, Kansas, where she practiced dentistry for more than thirty years.[30]

At the time of Dr. Taylor's death, there were more than a thousand women dentists practicing in the United States.[31]

"The File, as a Dental Instrument"

By W. W. H. Thackston, MD, DDS
The American Journal of Dental Science
May 1, 1867

[Dr. Thackston's article promoting the use of a file when working on patients' teeth was inspired by Dr. Lucy Hobbs's dental paper on using a mallet when filling teeth that she presented to the Illinois State Dental Society in 1866.]

Progress, is not always improvement. Change, as often travels downward, and backward, as upward and onward; and fashion, with its frailties and follies, plays not less fantastic tricks in the domain of science, than upon the broad surface of society. In this day of "radical" and startling change in the world without, and the world within, may be profitable to get back to some of the old "landmarks," and take a "new departure."

The furor for vulcanite and coralite, for cheoplasty and chisels, for gouges and drills, for automatic and pneumatic pluggers, for rubber wedges and wooden wedges, for mallets, and may we not anticipate—for sledges and tilt-hammers, for amalgams, "Hill's stopping," Oxide of Zinc, and "Woods' metal," for shredded gold and sponge gold, for the thousand and one new things that thrust themselves upon us at ever turn, has appeared from our point of view, to cause many to overlook, or almost forget, a great deal that is old and tried, and which has been found true and reliable, and among other things, one of the oldest, simplest and yet when intelligently used, one of the most valuable and efficient instruments ever placed in the hands of the dentist.

The file, if not forgotten, seems only to be remembered to be decried and denounced in some "new light" Dental Associations, where prayers and politics, psalm-singing and soft-soldering-dental patents and "duplex elliptics" combine in one harmonious and delightful mélange; and abundantly betoken the present status, and illustrate the present progress of American Dentistry.

No one attaches greater value or places a higher estimate upon the operation of "filling teeth" when the work is done in a proper manner, and with a suitable material, than the writer of this article. "Tooth-filling"

must ever constitute one of the leading features in dental surgery, and excellence in this individual operation, may well repay, and richly compensate a lofty ambition. And further, no one has a higher appreciation of the better class of operations usually denominated "mechanical" or "artificial," these are all indispensable, and invaluable in their several and proper places.

But with the foregoing acknowledgment and concessions, we maintain, that the (now almost obsolete) use of the file, is equally necessary to the best results desirable from correct dental practice—both in a prophylactic and remedial sense. A long, and somewhat critical observation in our own practice, and of the work of some of the Fathers of dental surgery (who have filled up the measure of their usefulness and honor, and passed away) as well as the practice of some of the most eminent who still survive, has abundantly satisfied us, that untold numbers of teeth are permitted to become the subjects of disease and decay, particularly upon their approximal surfaces, that might be protected, and preserved by the judicious use of the file. And more than this—that thousands of teeth are sacrificed to a blind and over-weening confidence in the operation of "filling." If compatible with the limits of this paper, or the object we have in view, we could present numerous and well authenticated instances in our own, and in the practice of more distinguished operators than we claim to be, of the permanent preservation of teeth by the file; which had been adjudged hopeless and incurable, so far as "filling" or any other operation could affect them, and which were filed as the only expedient, or experiment that could be applied. We have seen in the same denture, part of the teeth lost, under the best efforts of those most skilled in the operation of "filling"; and the remaining teeth, which had been abandoned as hopeless—a little mutilated, it is true, but sound and healthy, and satisfactorily performing all the functions peculiar to these organs.

We do not propose now to enter into any description of the file, its modifications of shape, its qualities of temper, cut or finish; nor do we design any observations upon the indications for its employment, or the best and most judicious methods of using this instrument, these subjects will all be more completely and clearly treated at another time, and in another place.

Our object in penning this article, is simply in our own plain way, to call back the attention of dentists, to an old, invaluable, but almost ignored or forgotten instrument; which used with judgment and skill has, and will continue to confer on humanity a blessed boon; and upon dental science, some of its proudest trophies, and most brilliant triumphs. We wish to direct in some degree, the attention of the profession, from utter

absorption in the more doubtful and questionable features, methods and materials of modern dentistry; and induce practitioners, to consider well, if they have not already lost a vast amount of valuable substance in the eager chase after shadows, if they are not throwing aside old and better friends, than they are likely to make from ephemera of the present day. We are not inimical to true progress and improvement, we are not wedded to old things, because they are old; but experience has taught us to repose very little confidence in, and attach very little value to what is simply new.[32]

Fannie Dunn Quain

Physician Fighting Lung Disease

For many years Dr. Dunn Quain was one of the driving forces in the fight against tuberculosis on a national scale.

THE BISMARCK TRIBUNE, FEBRUARY 1950

WHEN THE NORTH DAKOTA STATE LEGISLATURE DECLARED WAR ON tuberculosis in 1906, Dr. Fannie Dunn Quain was on the front lines, leading the charge. Tuberculosis, also known as consumption, an infectious lung disease, was the leading cause of mortality in the United States. It was the largest health threat in major cities such as Chicago and New York, where more than twenty thousand sufferers were dying a year.[1]

Although North Dakota's population size was considerably lower than that of Illinois or New York, the disease couldn't be dismissed in the upper Midwest section of the country. Since entering the medical profession, Dr. Quain had treated many patients struggling and slowly wasting away with consumption. There was no reliable treatment for tuberculosis, and she was dedicated to not only eradicating the illness but also educating the public about the disease. The doctor was thirty years old when she joined the National Tuberculosis Association and was an influential member of the organization for the bulk of her career.[2]

Born Fannie Almara Dunn in Bismarck, North Dakota, on February 13, 1874, she found an opportunity to teach presented itself before the idea of becoming a doctor was realized. Fannie's parents were John Platt Dunn and Christina Dunn. Her mother was a dressmaker, and her father

Dr. Fannie Dunn sits, posed, for a graduation portrait from the University of Michigan, 1899. State Historical Society of North Dakota, Collection: 00091.

was a pioneer druggist in the territory and mayor of the town. She was a middle child and the only girl. The Dunn's family home was always filled with extended family and friends who had played important roles in the history of the Dakotas. Among the men and women Fannie spent time with as a small child were the Seventh Cavalry officers and their wives from Fort Lincoln, including some of whom had died at the Battle of the Little Bighorn.[3]

Fannie attended primary school in Bismarck and graduated from high school there in 1890. Desiring to continue her education, she enrolled at the St. Cloud Normal School in Minnesota and studied to become a teacher. Just prior to leaving the area, Fannie witnessed a massive prairie fire that threatened to consume her family home and the town in which she was raised. The flames were contained twelve miles outside the city. It left a scorched section of land several miles wide in its wake. Crops, grain, houses, barns, and livestock were destroyed in the blaze. According to Fannie's recollection of the incident, "the country between Burnt Creek and the northern border was all black as a plowed field."[4] The image of the way the land looked was seared in her mind when she left North Dakota for Minnesota.

Fannie's teaching career began at a country school twenty-eight miles from Bismarck, in Ecklund. She had not yet earned her teaching degree, but young women who wanted to help children learn to read and write were so scarce in the area that the school board agreed to forgo the technicality. Ecklund was a long way from recovering from the fire that had swept through the area. Fannie later recalled the day her father drove her from their house to the location where she was to report to work. "It was my first venture on my own," she noted in her memoirs,

and when clouds darkened the sky on that 3rd of April, they made the departure for the unknown more depressing. The first twelve miles father knew the names of all the homes that we passed, and the ride was rather pleasant, then suddenly came the change to the black country.

As far as the eye could see in any direction, the earth was soot black, and the sky was only a shade lighter. Eighteen miles through burned grass. Wagon wheels had worn the grass away, and the gray

earth showed through in contrast to the black prairie, marking a trail winding, in the way of the least resistance as horse trails do, to the horizon.

It was about two o'clock when we reached the top of the small elevation and looked down upon what was to be my home for the next six months. We were looking at the home of Ole Anderson, a cluster of sod buildings of all shapes and sizes grouped around a well. The well was conspicuous because it was the only thing in the collection that did not have a wall and roof of sod out of which were standing the stalks and seed heads of last year's sunflowers. This place was known to the neighbors as "Sod Town." One could hardly distinguish the buildings from the surrounding gloom.[5]

The Andersons were enthusiastic about Fannie boarding at their home. They welcomed her with a hug and praise for the job she had committed to do. Fannie was charmed by them but was a bit apprehensive of the sod house.[6]

She later wrote about the accommodations,

The kitchen had an earth floor, but the best part of the house had a pine floor so white that I feared to step on it. The inside of the house was lined with building paper to keep the dirt from falling onto the floor. There was a great cottonwood log for a ridge pole and from this matched ceiling boards slanted either way to the eaves. This ceiling and big log had been whitewashed as had the window casings. These windows were the redeeming feature of the house. They were cut in the walls, which were three feet thick, and boxed in, with the window set in the outside edge. This made a wonderful place to curl up in on a rainy Sunday and read.[7]

The school where Fannie taught was a mile and a half from the Andersons' house. It was unlike anything she imagined it would be. The building was a renovated storehouse for the threshed grain. There were two windows on either side of a blackboard that hung on the wall behind a crude, wooden table that would act as the teacher's desk. The classroom was big enough for a dozen students. Each student was furnished with

a desk made of two upright boards slanted at the top with a shelf below for books. "The room leaked all around, and the floor had come to life," Fannie recalled years later. "Every two boards made a tent clear across the floor, and the water stood between, so we had to walk on the ridge to keep our feet dry. It was cold and damp, and the first few days we had no stove where children could be dried when they came to school wet. This improved when a stove was set up in the dark corner."[8]

Fannie enjoyed teaching but was fascinated with the medical profession. As a young girl, she had spent time with her father at his pharmacy and become acquainted with a number of doctors, who had inspired her to become a doctor. In addition to working as a schoolteacher to save money to attend college, she was also employed as a bookkeeper. In September 1894 the US surveyor general for North Dakota provided Fannie with the letter of recommendation she would use to secure her position.[9]

"She is a young lady of bright attainments and exemplary character, kind and obliging," the government official wrote. "She has been engaged for the past year as a typewriter in this office and has given the best of satisfaction. [She is] quick and accurate and pays strict attention to all the details of his work. She is capable of filling any position that she may ask for."[10]

When Fannie was financially able, she enrolled at the University of Michigan Medical School. She attended class with 150 other students, 17 of whom were women. Seventy-five of the 150 completed school, and 13 of those were women. "Therefore, we girls in the class have always pointed with pride to the fact that girls proved to be better students than our male counterparts," Fannie later commented on her college years.[11] One of the women Fannie attended school with was Katherine Crawford. Katherine became 1 of only 150 black female physicians in the country in the early 1900s.[12]

Fannie Dunn graduated from the University of Michigan in 1898. She interned at a hospital in Minneapolis and, for a while, entertained the idea of staying on with the facility as one of its resident physicians. Ultimately, she decided to return to Bismarck, where doctors were in short supply. She became North Dakota's first female doctor.[13]

News that Fannie had plans to move back to her hometown and open a practice made the July 11, 1899, edition of the *Bismarck Tribune*. "Miss Fannie Dunn, who graduated in medicine at Ann Arbor and who has been taking a practical supplemental course in nurse's work at the Northwestern Hospital in Minneapolis, returned to Bismarck today," the article read. "It is understood her friends are urging her for an appointment as woman physician at the insane hospital to fill the present vacancy."[14]

Dr. Dunn opened her own practice within days of coming home to North Dakota. In no time her business was thriving. It was doing so well that she declined the offer to serve as assistant physician at the asylum. Fannie wasn't interested in pursuing additional medical jobs outside her practice, but she did agree to run for the office of superintendent of schools. If elected, she promised to help other young women who desired to study medicine become doctors themselves. Fannie won the election by a considerable margin.[15]

The enthusiastic doctor traveled all over Burleigh County to attend to patients. She delivered many babies, set broken bones, treated pneumonia, and removed a bullet or two. In 1901, one of her patients had

Dr. Fannie Dunn Quain stands with her bicycle in Bismarck. State Historical Society of North Dakota, Item no. 00252.

been to see her regarding abdominal pains, which the doctor diagnosed as appendicitis. She explained to the gentleman that he needed surgery, but he decided to put it off and travel more than ninety-eight miles away for a job. En route the patient became ill and decided to consult a doctor where he was located. The doctor thought it best to send the man to see a specialist in Brainerd, Minnesota, for help. Fannie's patient sent her a telegraph letting her know what had transpired and that he was taking the train to Minnesota. Dr. Dunn was certain his appendix was in danger of rupturing and believed he'd never make it to Brainerd, some five hours away, without dying. The doctor was determined to reach the man and perform emergency surgery. After quickly weighing her options, she decided the only thing to do was try and catch the train using a railroad handcar.[16]

Dr. Dunn hurried to the train depot and explained the situation to a group of railroad employees, who helped her locate a handcar. A section boss on duty refused to allow her to use the vehicle unless he was on board. Fannie happily complied because she anticipated she'd need help pumping the lever. Unfortunately, the section boss, who had been drinking, was too drunk to lend a hand. Three high school boys watching the scene unfold offered to be of assistance. The teenagers hopped onboard and quickly began working the lever. With Fannie's help the makeshift railcar crew quickly traveled the six-mile distance between Bismarck and Mandan, where the train carrying her patient had momentarily stopped. She managed to reach her patient just as the train was pulling away from the station. Fannie then escorted the seriously ill man back to a hospital in Bismarck, where she removed his appendix.[17]

Dr. Dunn periodically returned to her alma mater to expand her medical expertise. In November 1900 she enrolled in a three-month course on diseases of the eye and ear. The following year, she took a course on infectious lung diseases.[18] That particular area of study sparked an interest that would lead to the building of the first sanitarium in the state.

While working at the St. Alexius Hospital in Bismarck in late 1902, Fannie met a surgeon named Dr. Eric Peer Quain. The pair conferred on a case and, soon after, fell in love. Fannie and Eric were married on

March 25, 1903.[19] The March 26, 1903, edition of the *Bismarck Tribune* reported,

> At the home of Mr. and Mrs. John P. Dunn last night at 9 o'clock took place the wedding ceremony which united in marriage Dr. E. P. Quain and Miss Fannie Dunn of this city. The wedding was a surprise to all but the most intimate friends of the bride and groom, so quietly had all the advance arrangements been conducted. . . . The bride was gowned in a handsome dress of white satin, and, after the ceremony, congratulations were extended by the guests present. A wedding supper was served after the ceremony, and the bride and groom left on the night train for Baltimore where they will remain for several months, after which they may make a European trip. . . . The bride has a wide circle of acquaintances and friends who admire her for her worth and sterling character. Dr. Quain is one of the best-known physicians in Bismarck and the western part of the state who has built up a large practice and is a skillful and able professional man. Dr. and Mrs. Quain will return to the city at the completion of their trip and make their residence in the city.[20]

Fannie continued working her successful practice and dividing her time between her patients, new husband, and researching tuberculosis. Four hundred fifty Americans were dying of consumption every day, most between the ages of fifteen and forty-four. The disease was so common and so terrible that it was often equated with death itself. Fannie was preoccupied with finding the best way to treat tuberculosis sufferers who visited her office. She became a member of the National Tuberculosis and Respiratory Disabled Association and set her sights on creating a statewide chapter. Tuberculosis was highly contagious, and she wanted people throughout North Dakota to know how to prevent and treat the illness.[21]

Shortly after Dr. Dunn Quain's daughter Marion was born in 1908, she met with Burleigh County school superintendents to encourage them to ensure that children were educated about tuberculosis. Fannie wanted teachers to make students aware of the disease and how they

could make a difference by keeping their hands washed and covering their mouths when they coughed.[22]

By early 1909 Fannie had helped establish the North Dakota Tuberculosis Association and helped craft a bill that was introduced and passed in the state senate for the construction of a sanitarium for those suffering with tuberculosis.[23] The February 26, 1909, edition of the *Bismarck Tribune* reported,

> The amended bill establishes the North Dakota Tuberculosis Sanitarium and provides for the organization of the board of management, which is named in the bill. The members of the board are the governor, Dr. Ruediger, state bacteriologist, Dr. Grassick, state health officer, Dr. Fannie Dunn Quain of Bismarck, and C. J. Lord of Cando.
>
> Within a reasonable time after the taking effect of this act the said board hereby created shall affect a permanent organization by the election of the usual officers of boards of similar character, which organization shall be accomplished at meetings to be held at the seat of government on call of the governor and by giving ten days' notice thereof. Meetings thereafter shall be held at such points as in the opinion of a majority of said board shall be most convenient. Said board shall receive as compensation for its services the sum of $3 per day and their actual and necessary expenses while engaged in the work provided for herein, to be paid as other expenses for boards of trustees of state institutions; provided, that no member of said board receiving a salary from the state shall receive anything save his actual and necessary expenses.
>
> An appropriation of $10,000 is made for the purchase of the site and for the necessary expenses of the organization and conduct of the affairs of the board. The site is limited to 160 acres of land, and it is to be forested and improved.
>
> The character of the commission indicates that good work will be done. Dr. Fannie Dunn Quain, one of the members named, is a well-known resident of Bismarck, and she has been deeply interested in the campaign against tuberculosis. Her selection as a member of the board is a nice compliment to her personal and professional standing in the state.[24]

Sun Haven State Hospital opened to patients in November 1912 in the Turtle Mountains near Dunseith, North Dakota. In 1913 the sanitorium accommodated twelve patients. In 1920 there were 90 patients and 140 patients in 1922. The cost to receive treatment at the facility was $1.50 a day. Patients had to follow a strict regimen of diet, exercise, and rest. They were encouraged to spend as much time as possible outdoors.[25]

A year after Fannie's son Buell was born in May 1912, the dedicated physician was appointed as a delegate to the International Congress on Tuberculosis in London. When she returned from Europe, she decided to close her practice and concentrate on eradicating consumption.[26]

Between 1913 and 1933, Dr. Quain served in every office of the state tuberculosis association and represented it on the state health advisory council as well as in the National Tuberculosis Association. Under Fannie's direction, school nurses were introduced into North Dakota schools, health seals were sold to help financially support the work,* health habits were publicized, and clinics for treating infants suffering with the disease were created.[27]

Throughout the 1930s and 1940s, Dr. Quain worked to address issues facing women physicians trying to make inroads in a male-dominated profession. She served as regional director of the Medical Woman's National Association for the states of North and South Dakota, Minnesota, and Iowa.[28]

Dr. Fannie Dunn Quain died of a heart attack on February 2, 1950. "Tributes to people like Fannie Dunn Quain can never be wholly adequate," her obituary in the February 4, 1950, edition of the *Bismarck Tribune* read. "Let it now be said of her simply that the good she did will live long after her, both in the memories of people and the works she started." Dr. Dunn Quain was seventy-five when she passed away.[29]

* Labels placed on mail during the Christmas season to raise funds and awareness for charitable programs.

The Tuberculosis Treatment

Public Health Report, vol. 41, no. 5
August 27, 1921

The following are the first symptoms of tuberculosis:

1. A cough lasting more than a month (except whooping cough, in which the cough lasts six weeks or more). Such a cough may not, of course, mean tuberculosis, but it certainly calls for a thorough medical examination.
2. Hoarseness lasting several weeks.
3. Poor appetite (especially in the morning), indigestion, loss of weight and or strength, paleness, and generally run-down condition ("that tired feeling").
4. Hawking and spitting, especially in the morning.
5. Night sweats.
6. A streak of blood in the sputum.
7. Afternoon fever, shown by flushed face and alternating with chilly sensations. The spittle has to be examined for the tuberculosis germ. But it must not be concluded that there is no tuberculosis if this germ is not found, not even after several examinations. The test is absolute if it is "positive," not so if it is "negative." In doubtful cases the x-ray should be used.

The following are the modern principles of the treatment by which most early cases can be cured, many even advanced cases arrested in their development; and by which comfort, and relief can always be assured. These principles can be pointed off on the thumb and fingers of one hand.

First, there must be careful disposal of the sputum of the consumptive—practically the only means by which the disease is conveyed from one person to another. The handkerchief or a cloth must always be held before the patient's face when he coughs or sneezes or spits out; thus, a droplet or spraying or atomizing infections is avoided.

The patient's handkerchiefs, towels, linen, bed sheets, and the like must be boiled by themselves before being added to the general wash.

Whatever can be must be burned. The spittoon must contain some fluid (water will suffice) in order that the sputum may not dry and become incorporated with the dust. And the spittoon, when cleaned, must be scalded; this will kill the tubercle bacilli, the germs of the disease.

Secondly, there must be rest. There is otherwise, no hope for the patient's emaciated body, an organism on the verge of bankruptcy. Here is, of course, a factor difficult of management, especially among the poor (who furnish the majority of the cases), many of whom feel that they must somehow work in order to maintain themselves and their own. And yet there has to be rest, especially when there is a fever; and at least until the sufferer has recuperated from the exhaustion which has been the prime predisposition to this disease. For the consumption, germ fattens on devitalized tissues.[30]

Harriet Belcher

Beloved Santa Barbara Doctor

I am having the usual experience of beginners, the patients come in,
but slowly, but all who have lately come tell me of being sent by some-
one who has given me a hearty recommendation.

DR. HARRIET BELCHER, MARCH 1881

A TEAM OF BALD-FACED HORSES PULLING A BUCKBOARD WAGON GAL-
loped wildly along a dirt road, heading toward the Santa Ynez Mountains,
twenty miles outside of Santa Barbara. The driver, a pudgy man wearing
a worried expression, urged the animals along. Dr. Harriet Belcher, a
distinguished-looking forty-year-old woman with dark hair and dark
eyes, held tightly to the railing next to her seat with her right hand and
clutched a leather medical bag to her chest with her left. The doctor had
been summoned to help a young man suffering with erysipelas, a bacte-
rial infection in the blood that had spread to the heart valves and bones.
His condition was serious, and Harriet was needed right away.[1]

The driver and passenger rode through the rough country of deep
creeks and high ridges. It was eight thirty at night when they came to
a creek that was off the beaten trail, which the horses balked crossing.
Tall black mountains loomed before them, and a half-moon emerged
from behind a cluster of clouds. Though she didn't know for sure,
Dr. Belcher sensed they were lost, and she wanted to cry from sheer
hopelessness. A man's life depended upon her, and she was anxious to
get to the patient.[2]

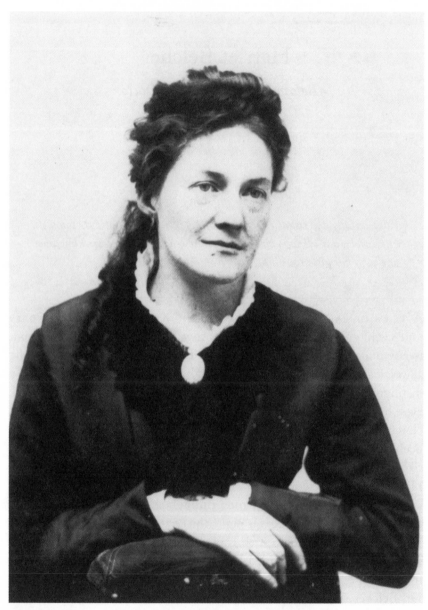

Dr. Harriet Belcher. Gledhill Library Photograph Collection, Santa Barbara Historical Museum.

The wagon hurried along over rocky, winding paths and under dense stands of oak trees. A singular pack of coyotes was standing in an open space at the top of a hill, and it quickly scattered without making a sound as the vehicle approached. After dragging the wagon over a row of tree trunks, the driver brought the horses to a stop. He hopped out of the wagon and hurried ahead of the team on foot. He returned moments later, climbed back into the vehicle, snatched up a whip resting beside his seat, and snapped it at the horses. The wagon jerked forward, and the team proceeded down a steep embankment into a dry streambed, over boulders, and up the opposite bank. The wagon creaked and groaned, and Harriet feared it wouldn't make it to their destination.[3]

It was just past sunup when the doctor and driver reached the home of the ill man. Dr. Belcher treated the patient and stayed by his side until he was resting comfortably. When it came time to return to her office in Santa Barbara, the doctor informed the driver that if the trip back wasn't any better, then she was going to walk home. The driver assured Harriet he would do better traveling by daylight. He was true to his word and had the doctor back at her desk by noon.[4]

House calls in rugged California proved to be dramatically different than those Dr. Belcher had gone on in Rhode Island, where she was first employed as a physician. Horse-drawn carriages transported her down cobblestone streets there, and the risk of getting lost in the wilderness was virtually nonexistent. It was for Harriet, however, too tame a location to practice medicine. She wanted to be challenged, and when the opportunity to go to the West presented itself, she had quickly taken advantage of the offer.[5]

Harriet Gilliland Belcher was born in 1842 in Clinton, New Jersey. Her parents were Charles and Caroline Belcher. Charles made and calibrated rulers. Harriet's mother passed away when Harriet was twenty-one. She helped care for her two brothers and two sisters until they were grown. Shortly after her youngest sister married, Harriet enrolled at the Woman's Medical School in Pennsylvania. Founded in 1850, the prestigious school was one of the first medical colleges for women in the world. Some family members didn't approve of Harriet wanting to leave home to study medicine, but she was driven and wouldn't allow the objections to keep her from pursuing her passion.[6]

While in school, she exchanged letters with her friend Elizabeth Johnson. In a letter dated October 22, 1875, Harriet shared a list of the courses she would be taking. They included chemistry, *materia medica*, physiology, and anatomy. She also attended surgical and obstetrical clinics. "There is quite a large class of students—most of them refined, earnest, cultivated women," Harriet wrote Elizabeth. "There are some strange looking specimens, certainly, but very few . . . The corps of professors is a very pleasant, and, so far as I am able to judge, a very competent one."[7]

In her second year of college as a resident student, she applied for a position at Boston Hospital. She was accepted and, by early 1878, was assisting in clinics and visiting patients. "This is a specifically hard time for money and work, and we come across some heartrending cases," Harriet wrote her friend Elizabeth about her time at Boston Hospital. "I am learning many lessons besides the professional ones, and not the least is to be more thankful each day I live for the happy, protected life I have had."[8]

Harriet received a well-rounded, practical education at the New England hospital. She was rotated to various areas of the facility for training, including the maternity department. "Imagine me with eleven babies on my hands at once, to say nothing of their mothers, and of bringing them into the world," Harriet wrote on September 23, 1877. "This maternity is the saddest of places to me. Most of the women are unmarried, and except for the respectability of the thing, by far the greater number had better not be—the husbands being brutal wretches who abuse them."[9]

Harriet was expected to accompany working physicians on their regular appointments at the hospital as well. The experience was both trying and instructional, as were those at the other clinics in which she was required to participate. On January 20, 1878, she informed her friend Elizabeth of the following:

Clinics are held every morning except Sunday. One of the head doctors comes, sees all the patients in turn, questions, and then prescribes gratuitously medicine or treatment or both. For which they are able,

they pay a trifling sum. On two mornings, clinics begin at 8. We often have between 70 and 80 patients. I have charge of a backroom and five mostly uterine examinations and treatment, but also examine hearts, lungs, bandage etc. On two other mornings I make up prescriptions in the clinic room, and on the other two can listen or go out to see patients as I choose.[10]

Harriet graduated from medical school in 1879 and was conflicted about what to do afterward. Some had suggested she move to Burlington, Vermont, because the community needed a woman physician. She also considered entering the mission field and traveling to either China or India to serve as a doctor. She decided to move to Pawtucket, Rhode Island, to practice medicine.[11]

In a February 9, 1880, letter to her friend Elizabeth, Dr. Belcher shared details of a few of the cases in which she had an opportunity to take part. There was the young girl who was convinced she was suffering from cancer and an elderly lady who had injured her eye so severely that Harriet referred her to a specialist, as well as a woman who needed an operation to extract germ cells.[12]

"Five physicians, all women, opened the abdomen and removed two small ovarian tumors and one of another kind," she wrote Elizabeth. "Then for three weeks, I remained and took care of [the patient] night and day. I can't tell you what a mental and physical strain the first few days were, nor the utter thankfulness with which we saw her coming through safely . . . Success or failure was so much more to us professionally than it would have been to men."[13]

Apart from those cases, there weren't many people for Harriet to see, and the patients she did have could only pay for her services in gratitude. The only hope she had of earning a living in Rhode Island was if one of the female physicians she worked with from time to time would take a job elsewhere and those patients were then sent to Harriet. When that didn't transpire, Dr. Belcher accepted an invitation to visit Santa Barbara to take the place of a doctor who was retiring. By February 1882 Harriet had moved to the location where the previous woman physician had her practice. It was a single-story home with four rooms. Dr. Belcher used

one room as a waiting area, one for storing supplies, one as an examination room and private office, and the smallest room as her sleeping quarters.[14]

In less than a month after setting up her practice in Santa Barbara, Dr. Belcher had seen more patients than she had in her entire time in Rhode Island. The regional newspaper, *The Independent*, ran a short piece on Harriet's arrival to the area and elaborated on her work. "Miss Belcher, our new resident physician, is swiftly and surely winning the ears and confidence of the ladies of Santa Barbara," the article read. "Her success and popularity are unquestioned."[15] Harriet shared the report with her friend Elizabeth in a letter dated February 17, 1882. She joked with Elizabeth that she believed the writer of the short piece was so complimentary because she had treated a case of hemorrhoids for him, and he was grateful.[16]

Not only was Harriet pleased with her business and the diverse cross section of people in the region, but she was also quite taken with the picturesque coastal city. She wrote Elizabeth,

> There is hardly too much said of the beauty of the place, though I think many places I have seen in the East excel it on the whole. I have seen nothing that is to me as grand or as beautiful as some of the scenery in the White or Green Mountains, but it is different and has a charm of its own. The air is exquisite most of the time; the sunshine seems to flood and permeate everything. The mountains encircle us except toward the south, clear cut against the blue of the sky and melting away in a haze into that of the sea.[17]

Dr. Belcher's office hours were 10:00 a.m. to noon and 2:00 p.m. to 4:00 p.m. six days a week. During the winter, the doctor treated the citizens who lived in the area year-round. From April to October, vacationers visiting the waterfront community or en route to national parks such as Yosemite specifically sought Harriet's services if they were needed. When she wasn't working, she was attending church gatherings and enjoying horseback riding, walks along the beach, and picnics with friends.[18]

Most of the cases Dr. Belcher had from day to day were necessary but unexciting. She successfully treated many individuals and was well respected. Harriet didn't remember those that benefited from her work as well the one patient who died in her care ten months after she had begun treating people in California. It happened on Christmas Day in 1882. It was a "sad and fatiguing experience" she confessed to Elizabeth. "At noon, I lost the only case which I have lost here, when the patient has been under my hands all through . . . a very bad one of gastritis and diphtheria combined," she wrote. "I spent the night with her and the day with the most intimate friend I have made here, who had a few days before received news of the sudden death of her only sister and had become insane. She is now improving so that I have strong hopes of her ultimate recovery."[19]

Dr. Belcher treated patients' physical problems and helped them emotionally. It wasn't unusual for residents to seek out her advice for everything from how to treat an ear infection to how to handle marital issues. Harriet confided the following in a letter to Elizabeth dated September 16, 1883:

> The study of human nature as seen from the standpoint of a physician grows more and more interesting to me. Most of us act, more or less unconsciously, to the world in general, but there come times when, for the physician, all disguises are stripped off, and I am sometimes almost appalled at the knowledge I have of the inner lives of those who come to me, often far more than they are in the least aware of, much of it painful beyond expression, and yet, as one of the other doctors said not long since, "No one knows so well as we how much of good there is in humanity."[20]

Not long after Harriet had arrived in Santa Barbara, the doctor noticed issues with her own health. She complained of being cold much of the time and of feeling tired and listless. She worried about the condition so much so that, at times, her friends and neighbors feared she would suffer a nervous breakdown. A fellow physician diagnosed her as suffering from malaria. To help aid in her recovery, she took a trip to Ojai, California, forty-eight miles east of Santa Barbara. She spent a great deal

of time horseback riding through lush hillsides and in the mountains. She ate plenty of fruits and vegetables and daydreamed about the new home and office she would have built when she was doing better.[21]

Dr. Belcher's patients were anxiously waiting to see her when she returned. Her health was restored enough to go back to work, but she wasn't completely better. She hoped in time she would be. In October 1885 she explained to her friend Elizabeth how busy her practice had been and the toll it had taken. The letter also included details of the life-saving medical procedure she had performed on a young woman. Harriet wrote,

> I have had a fatiguing summer on the whole not only rather more business than usual at this season, but several cases which have caused me a good deal of anxiety and none the less that they have been of a kind to occasion rather a furor among the gossips, of which we have the number proverbial in small towns.
>
> One was a case where I took off a breast for cancer, though two other physicians here had not considered that disease. I proved right, however, and my patient has recovered despite a feeling among some of her friends that she would die because I had operated. Another was the worst case of hysteria that I have ever had on hand—and fifteen miles out in the county, too, and I can assure you it is not the easiest thing in the world to take a thirty-mile drive sometimes several days in succession. I had eight weeks of that, and finally married her off and sent her to a cold climate, where at last accounts she is thriving.
>
> Hardly had I sent her off when one of the homeopathic physicians came and asked me to take a case of puerperal insanity off of his hands, and though I have no doubt of her ultimate recovery, it may not be for months, and both she and her baby were in a wretched state and gave me no end of anxiety at first. I am glad on the whole that I am in a small place where I cannot have a really extensive practice, for I think that I shall never break myself of taking every case to heart and worry over it as if it were all perfectly new to me.[22]

A construction crew broke ground on the building of Dr. Belcher's new home and office in mid-July 1886. Harriet hired the carpenters herself. She

wanted a sturdy house that could withstand the test of time and was "very prettily finished inside."[23] By September Harriet was living and working out of her new location. "The house is perfectly satisfactory in price and all," she later noted in a letter to Elizabeth, "and my lot has already more than doubled in value since I bought it."[24] The doctor had acquired a loan to build her home office and believed that as her practice grew and if she were able to keep well, she'd be able to pay off the debt in time.

Unfortunately, Dr. Belcher's health continued to deteriorate, and in the spring of 1887, she required two different surgeries to treat chronic regional enteritis. In what would be one of the last letters sent to her lifelong friend Elizabeth, she explained her diagnosis after the procedure. "It is still exceedingly doubtful whether I shall recover as before, and be able to lead an active life, or whether I shall be more or less of a chronic invalid, with probability of sudden death, which, I earnestly hope, in such a case would come quickly."[25]

According to those closest to Dr. Belcher, the stubborn physician was in control of her own case. She remained lucid throughout the postsurgical care and instructed attending nurses what to do. She fully realized she would soon die and wasn't intimidated by the prospect. She made all the preparations for her death and burial and continued to be loving and kind to all in those last days.[26]

"I don't expect to hold a pencil again, as I have not been able to for several days, for my wish is granted, and I am dying in the midst of my life and work, and though there are plenty [of people] to write to you, I wanted to say goodbye myself," Harriet wrote her brother Stephen on May 16, 1887. "I wish I could see some of my own—it is about the only wish I have left except that the end should come quickly, and it is likely to; my affairs are pretty straight, and all provided for."[27]

Dr. Harriet Belcher passed away on May 30, 1887, at the age of forty-five. The May 31, 1887, edition of the *Morning Press* reported that the doctor "came to this city about five years ago and from the start enjoyed a large practice in her profession, in which she stood high."[28]

Dr. Belcher was laid to rest at the Santa Barbara Cemetery. The tombstone at her gravesite reads "Much Beloved."

Dos and Don'ts for Influenza Prevention

[Found in doctors' offices across the West in 1918]

Wear a mask.

Live a clean, healthy life.

Keep the pores open—that is, bathe frequently.

Wash your hands before each meal.

Live in an abundance of fresh air—day and night.

Keep warm.

Get plenty of sleep.

Gargle frequently (and always after having been out) with a solution of salt in water. (Half teaspoon of salt to one glass—eight ounces—of water)

Report early symptoms to the doctor at once.

Respect the quarantine regulations.

Avoid crowds. You can get the influenza only by being near someone who is infected.

Avoid persons who sneeze and cough.

Do not neglect your mask.

Do not disregard the advice of a specialist just because you do not understand.

Do not disregard the rights of a community—obey cheerfully the rules issued by the authorities.

Do not think you are entitled to special privileges.

Do not go near other people if you have a cold or fever—you may expose them to the influenza and death. See the doctor.

Do not think it is impossible for you to get or transmit influenza.

Keep your hands out of your mouth.

Do not cough or sneeze in the open.

Do not use a public towel or drinking cup.

Do not visit the sick or handle articles from the sick room.

Don't worry.[29]

Romania Pratt

First Woman to Practice Medicine in Utah

Dr. Pratt led an active life and was one of the west's pioneer women in professional life.

THE SALT LAKE TRIBUNE, NOVEMBER 10, 1932

MORE THAN TWO DOZEN WOMEN DRESSED IN HIGH-COLLARED, MUT-ton-sleeved blouses and gray or black skirts, all members of the Church of Latter-Day Saints, occupied the chairs around a conference room at the *Woman's Exponent* newspaper office in the Salt Lake Valley in 1878. Most of the women were talking quietly among themselves; some were flipping through medical books and making sure they had paper and pencils. Others were studying an announcement in the morning edition of the publication.[1]

"Mrs. Romania B. Pratt, M.D., continues her interesting and instruc-tive free lectures to the Ladies' Medical Class every Friday afternoon," the announcement read. "All ladies desirous of obtaining knowledge of the laws of life and how to preserve their health, and rear children, and how to determine the cases of illness should improve with these opportunities and not fail in punctuality."[2]

The eager, makeshift classroom of women turned its full attention to Dr. Pratt when she entered. The coal-haired instructor with dark eyes and a broad nose smiled at the students expecting to learn something about anatomy, physiology, and obstetrics from the first female doctor in Utah. As she took her place in front of the group, she couldn't help but see

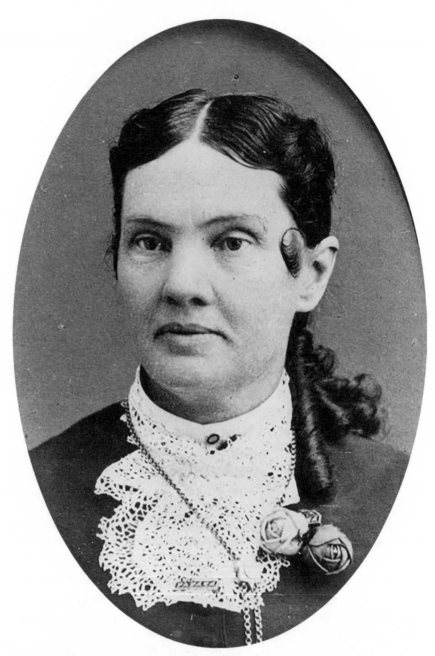

Dr. Romania Pratt. Utah State Historical Society.

herself reflected in the beginners. Five years prior to agreeing to act as a medical instructor, Romania had been encouraged to become a doctor by Mormon leader Brigham Young. The plea for women to pursue the study of medicine had been issued from the pulpit in 1873. Romania answered the call not only because she was enthusiastic about learning but also because she had personally experienced death and wished she'd been able to intercede. The death of a dear friend helped influence her decision to become a doctor.[3]

"I saw her lying on her bed, her life slowly ebbing away, and no one near knew how to ease her pain or prevent her death," Dr. Pratt recalled in her memoirs. "It was a natural enough case, and a little knowledge might have saved her. Oh, how I longed to know something to do, and at that moment I solemnly vowed to myself never to be found in such a position again, and it was my aim ever afterward to arrange my life work that I might study the science which would relieve suffering, appease pain, and prevent death."[4]

The future Dr. Pratt was born in Washington, Indiana, on August 8, 1839. Her father, Luther B. Bunnell, was a farmer, and her mother, Esther Mendenhall Bunnell, was a homemaker who gave birth to four children, two boys and two girls. The Bunnells were dedicated Mormons who followed church leaders to Nauvoo, Illinois, in 1846. Three years later, Luther decided to travel to California to try and find gold. He left his family behind, promising to send for them once he'd made his fortune. Shortly after Luther had arrived in the Gold Country, he contracted typhoid fever and died. Esther moved herself and her children back to Indiana in 1849.[5]

Romania attended school at the female seminary in Crawford, Indiana. Her primary education consisted of the usual subjects along with classes in music, painting, and foreign languages. In 1855 sixteen-year-old Romania and her family left the Midwest for Salt Lake. It was a four-month trip by wagon train, but the teenage girl didn't seem to mind. "The journey across the plains with ox teams was a summer full of pleasure to me," she recalled years later. "The early morning walks gathering wild-flowers, climbing the rugged, and, at times, forbidding hills, the pleasant evening gatherings of the young folks by the bright campfire while sweet

songs floated forth on the evening air to gladden the savage ear of the wild beasts as well as our own young hearts."[6]

The Bunnells reached their destination on September 3, 1855. It was a struggle at first to make ends meet; Romania's mother found work doing laundry and other household tasks for families, and Romania secured a position as a teacher at a Brigham Young school. Esther received an inheritance from a family estate in Indiana and used the funds to make sure her children had a home and plenty to eat. She purchased a piano for Romania, who proved to be as talented musically as she was academically.[7]

Romania's early life had been fraught with heartache and difficulties since the death of her father. It was her sincere hope after meeting and agreeing to marry Parley Parker Pratt Jr. that the rough times were behind her, but they weren't. Within the first two years after their wedding on February 23, 1859, Parley, whose father had been an influential apostle in the church, accepted a mission assignment to the East Coast. From there he was sent to England. During his absence Romania was the sole supporter of their family. Their first son was born in 1860 and their second son in 1862, dying three days after Romania gave birth to him. The Pratts were reunited in 1864. They had five more children together. Their only daughter passed away when she was twenty-two months old.[8]

Romania was thirty-three when she decided to pursue a career in medicine. She sold the piano her mother had given her to help pay to attend the Bellevue Women's Medical College in New York. When she left her children in Salt Lake in December 1873, the oldest boy was fourteen, and the youngest was ten months. She spent her first term in school watching and listening and making note of everything she observed. She had joined the semester late and needed time to catch up. She was able to get through her initial studies with the help of a tutor.[9]

The instructors at the college were unsympathetic to the fact that she was a latecomer who had missed out on the first months of training. They did not shy away from calling on her in class to participate. Romania recalled one such occasion in her memoirs:

I shall not soon forget my extreme confusion on being asked a question during a quiz by a professor who, for the moment, forgot I was a new student—nor the mischievous smiles of the students, but my revenge was more than complete at the beginning of the next term in witnessing their astonishment because of my advancement. During the summer vacation while they were recreating sea bathing and visiting with friends, I daily plodded studiously up the rugged hill of knowledge, reciting as a private student every day to the professor of physiology. I also took lessons on ophthalmology by Dr. P. A. Callan, and, finally by special permission, I joined a class taught by Professor H. D. Noyes in Bellevue College.[10]

Romania excelled in every subject at college. Her area of expertise was in dissection. Her dissection work was set aside by the teacher to show others how it should be done. Fellow students sought her out to give lectures on the subject.[11]

In the summer of 1875, Romania made a personal appeal to Brigham Young himself for financial assistance with her education. Young believed it was important for her to finish school. "We need her here, and her talents will be of great use to this people," he told Eliza R. Snow, secretary of the church's Relief Society. "See to it that the Relief Societies furnish Sister Pratt with the necessary money to complete her studies."[12]

Romania returned to college in the fall but decided to finish what she'd started at the Woman's Medical School in Pennsylvania. The list of courses she was required to take there was extensive. Between her sophomore and junior years, she studied obstetrics and diseases of women; anatomy; chemistry and toxicology; principles and practices of medicine, surgery, microscopy and histology; and dentistry.

Romania graduated college on March 15, 1877. Her senior year thesis was titled "Puerperal Hemmorrhage [*sic*], Its Cause and Cure." Upon receiving her diploma, she took a moment to offer thanks for making it through. "I mentally offered up a prayer asking our Father to so bless me that I might fully appreciate the privilege I then enjoyed," Romania remembered later about the day she graduated.[13] Although she had met all the requirements to leave school and establish a practice, she decided

to remain in Philadelphia to continue her studies of the eye and ear, which she chose as a specialized field of endeavor.[14]

During spring and summer breaks throughout Romania's college years, she worked at the New England Hospital for Women and Children in Boston. Her drive and dedication to the profession earned her the respect of the administration and staff. The physicians at the Elmira Water Cure Health Resort in Elmira, New York, where Romania served an internship, felt the same way about her. They were impressed with her inquisitive mind and devotion to patients. Romania wanted to put into practice the treatments at both facilities for eyes and ears and ailments women specifically suffered that were rarely acknowledged. She was fascinated with the various baths offered at the Elmira resort that were promoted as being beneficial for the "whole health" of the woman.[15]

"The different kinds [of baths] are hot air, (miniature Turkish) full, three fourths, sitz, foot, head and foot, pours, etc.; all finished up with such vigorous slapping and massage by robust Scotch girls that the sleepiest or half dead molecules of blood are sent madly coursing on their way renewing, enlivening and invigorating with new life every process of the system," Romania recalled in her medical notes.[16]

Dr. Pratt returned to her home in Utah on September 18, 1877. She was happy to be back with her husband and sons but troubled by the fact that her two youngest children didn't recognize her. Romania spent time getting reacquainted with her boys (the oldest, now seventeen and the youngest, four) but their reunion was cut short because she had to go to work. Parley was in poor health and couldn't support the family he had with Romania along with the second woman he'd married and fathered children with during Romania's absence.[17]

Almost from the moment she hung out her shingle, she was overrun with patients. An announcement that she was in business appeared in the April 3, 1878, edition of the *Deseret News*. "Dr. Romania Pratt has opened an office on East Temple Street, over the Richards' drugstore, nearly opposite Z. C. M. I.," the article read. "The lady has given special study to obstetrics, diseases of women and diseases of the eye and ear."[18]

The community in and around Ogden, Utah, where Romania had established her practice, benefited greatly from her work. She treated a

variety of maladies but excelled when it came to eyes. Whether it was dealing with injuries to the eyes, congenital malformation of the eye, or diseases of the eye, such as conjunctiva or tumors of the iris, Romania was an expert. Over the course of her career, she responded to many emergencies involving damaged eyes in youngsters. Such was the case in late June 1881.

"Yesterday afternoon, between 5 and 6 o'clock, Angus J. Cannon, a son of Hon. George Q. Cannon, age 13 years, met with a painful and serious accident at the family farm, southwest of this city," an article in the June 30, 1881, edition of the *Deseret News* began about an eye injury Romania was asked to evaluate.

> In company with a number of playmates, he was amusing himself with some firecrackers and having a broken one from which he thought the powder had been extracted, lit it for a torch. As it did not ignite readily, he endeavored to expedite the process by blowing upon it. While so engaged, the powder took fire and flew up into his left eye.
>
> He was at once taken into the house, where he received every care possible until the arrival of Dr. Romania B. Pratt who was sent for immediately. She cleansed out much of the powder, but some still remains inside upon the eyeball. The orb was much swollen last night and has been today, but the patient was feeling quite comfortable about noon. The doctor was not yet certain whether the sight can be saved but expresses a belief to that effect.[19]

Romania's counsel was needed to help older patients preserve their eyesight as well. She is credited with performing the first cataract surgery in the territory.[20]

In addition to her daily responsibilities as a physician, Dr. Pratt gave lectures to residents about the need for a hospital in the area and on the encouragement of women to enter the field of medicine. "It is good to become self-sustaining and have a complete knowledge of some branch of work," she told a group of men and women at city hall meeting room on May 31, 1879. "Our young ladies ought to become informed upon these matters, that they may be good mothers of the future race. Women must work her way up to the position she desires to fill in life, and her

mission as a mother is a sacred one. Nursing is a profession to be studied, one which needs preparation; a training school for nurses should be associated with a future hospital."[21]

By 1881 Romania's professional life was flourishing, but her marriage was faltering. Parley's inability to financially support her and the children they'd had together, his frequent mission trips that kept him away for long periods of time, and the years they were separated while she was at school had taken their toll. Their divorce was finalized in late 1881.[22]

Never content with limiting herself with what she knew about her area of health care, Romania traveled to New York in 1882 to attend lectures and consult on patients at the Eye and Ear Infirmary. Dr. Pratt learned that many people who sought help for what they perceived as serious issues with their eyes were only having trouble with their glasses being poorly suited for them. After receiving accurate diagnoses, getting proper measurements made, and spectacles in accordance with their stigmatisms being created, patients left the infirmary relieved. Dr. Pratt helped make crooked eyes straight and assisted in performing all manner of surgical operations. In all cases where cutting could be avoided and sight improved otherwise, she took the latter line of action.[23]

After six months on the East Coast, Dr. Pratt returned to her home and work in Utah. Among moving her practice to a new location in town, equipping it with the most up-to-date devices available, and treating the many patients who needed her services, Romania was busy helping to establish the much-needed hospital she had spoken of three years prior with Ogden citizens. The Deseret Hospital opened in July 1882 under the direction of the Relief Society. The society had collected substantial donations to fund the project. Dr. Pratt was appointed as visiting physician and served on the board of the thirty-five-bed facility.[24]

On March 11, 1886, Romania married newspaper editor, teacher, and farmer Charles W. Penrose. Although the two were busy with their individual careers, they found time to be together. They enjoyed traveling and attending the theater. Some of Romania's interests, such as journalism, were in line with her new husband's, and they talked at length on the topics. When the magazine *Young Woman's Journal* was founded in 1889 by one of Romania's good friends, Susa Young Gates, Charles

encouraged his wife to accept the invitation to serve on the board of the publication. As a board member, she also penned a regular column on hygiene for the paper.[25]

By 1907 Dr. Pratt had taken a break from her medical practice to accompany her husband oversees on a mission trip. She contributed several articles to the *Woman's Exponent* about her visit to the European countries where the pair had spent time. Romania and Charles returned to America in 1910. She began seeing patients again shortly after they arrived home. Her time back in the office was brief, however. At the age of seventy-three, after more than thirty years as a practicing doctor, Romania decided to retire. She continued writing and assisted Charles in his duties with the church. He passed away in May 1925.[26]

In the years after losing her husband, Dr. Pratt accepted invitations to tutor medical students and to speak at colleges and women's clubs on the best way to maintain good health both physically and mentally. When she wasn't working, Romania was with her adult children, grandchildren, and great-grandchildren. Dr. Pratt struggled with poor eyesight the last few years of her life, and by the time she died on November 9, 1932, at ninety-three years old, she was completely blind. She was laid to rest at the Salt Lake City Cemetery.[27]

Hygiene

According to Merriam-Webster, *hygiene is the department of medical science that treats the preservation of health: a system of principles or rules designed for the promotion of health.*[28] *The following article by Romania B. Pratt, MD, was published in the October 1889 issue of the* Young Woman's Journal:

There is no duty more incumbent upon an individual desirous of living a useful, moral, intelligent, and active life than the observance of the laws of health. We are dual in our organization, physical and spiritual, each dependent upon the health and vigor of the other. Spiritually, we are imprisoned or clothed upon by our physical nature.

Physically we are permeated, every molecule, by the spirit, giving it life and light. Physically "we are of the earth earthy," "prone to do evil as the sparks are to fly upward," requiring a code of laws to govern and guide us that we may enjoy that condition of harmony physically that will enable us to accomplish the greatest amount of work attainable with the talents given us spiritually.

No man or woman can work efficiently with broken or incompetent tools, neither can the talents or intelligence of the spirit be materialized to its greatest degree by a physical organization diseased.

The position might be taken as a self-evident fact that our spiritual natures at the time when they take possession of the physical are pure and without evil tendencies, as they are the literal offsprings of our Father and Mother in heaven and have been nurtured and trained in a school without guile. This holy essence to become eternally progressive requires the physical nature to make it a perfect soul, but this descent of our spiritual selves involves a contact, an environment, an association with grosser material, being surrounded with germs of evil—evil tendencies and hereditary taints and tradition of our forefathers. It is a school of agency, wherein the spirit can demonstrate its indisputable right to its eternal inheritance of the body.

The remembrance of the training of our spiritual or first estate, 'tis true is withheld, but the instinct of Godliness is inherent in every living soul, which is our guide in choosing the better way and rejecting that which is evil. Not heeding the voice of God within us but lending

ourselves to carnal or earthly influences only which stalk on the broad road and through the wide gate, we will end in destruction.

An unhealthy, diseased bodily condition benumbs, beclouds, and cripples our intellectual and spiritual powers and hinders progress in mental improvement and all physical labors which increase our own material welfare and comfort and of those dependent upon us. To investigate and possess ourselves of the knowledge of those laws of health which will put our bodies in the condition of greatest vigor physically, and to study and apply the lessons by the growth of the better attributes of our spiritual natures to the points of dominance, will change to our immense advantage and happiness the old proverb "the spirit is willing but the flesh is weak" into the spirit is willing and the flesh is strong and will lead to success in all laudable undertakings.

By common consent, it seems the two great workshops of the soul are the brain and heart—the brain presiding over our intellectual faculties and the heart over the emotions. The brain, to do good work, must have good nutritious blood and not too much at one time or too little at another but a supply equal to its work and relief from it when in a state of rest.

From the brain and spinal cord proceeds every nerve of the body as one continuous, unbroken fiber to the periphery as efferent and afferent nerves, by means of which all voluntary motions are produced. This system of nerves is most intimately connected with the great sympathetic system which presides over digestion, reproduction, and other functions of the body which are not under the control of the will.

If the blood be vitiated by respiring impure air, or closed unventilated rooms, or by bad, poorly cooked indigestible food, or irregularities of numberless kinds, the nervous centers are overcome and weakened by the presence of carbonic acid in the impure air and the lack of nutriment in the blood formed from poor food.

A telephone office and its points of connection are a very fair simile to the human body. Any deficiency in the central battery is felt more or less on all the connecting lines. One organ of the body cannot be diseased organically or functionally without the other organs being overburdened, thus destroying the harmony of our physical being.

"The connection between mind and body is so subtle that whatever stimulates or depresses the one has a reflex influence upon the other. It is the province of mind to dominate the body, and it should awake to the knowledge of its divinity by seeking, not ignoring, the divine laws of physical evidence."

The laws of hygiene should be a vital part of the education of every young lady, for her own personal comfort, usefulness, and advantage,

even if she does not assume the higher walks of life in caring for and directing the welfare of a family and home.

Hygiene in its general application refers more especially to physical life, but metaphysical hygiene is not a theoretical myth, but in truth is the pith of the teachings of the holy gospel. It is the hygiene of the heart which we may say is the home of the emotions, and of the brain which is presided over by that divine essence of life or ego, the offspring of divinity.

In physical hygiene, we consider the effects of pure and impure air, and water, of light, darkness, heat, diet, dress, sleep, temperance and intemperance, regular and irregular habits, and everything which demoralizes or harmonizes our physical existence.

Mental hygiene embraces the laws of mind which establish the supremacy of faith over infidelity, hope over despondency and darkness, charity over our selfishness, love over hate and jealousy, obedience over disobedience, fidelity over dishonesty, diligence over idleness, punctuality over indifference, order over disorder, and all the attributes of the soul which prepare us for a higher life and an association with celestial beings.

The Word of Wisdom in the Doctrine and Covenants is an epitome of physical hygiene to all who will reflect closely and carefully and comprehend the full extent of its meaning. The gospel, as revealed in these latter days, teaches us, as we sit under the sanctuary every Sabbath and many other days, in the plainest manner the most perfect mental hygiene the summary of which is: "Love the Lord thy God with all thy heart, mind, and strength. Do unto others as you would have them do unto you, and love thy neighbor as thyself."

Spirit has the right to control matter; matter should be the servant of the spirit. The spirits of the faithful acquire the power of controlling matter other than that composing their own bodies. By this power worlds are created and placed in their orbits, the sick are healed by the power of faith, and the power of the holy priesthood.

People in good health have become sick and actually died through being the victims of practical jokes. The following instance is in point. Several students arranged among themselves to test the statement that a person could be frightened into sickness or a specific disease by simply impressing the mind of the victim that he had been exposed to the disease.

They seized a fellow student and forced him into a clean bed but told him that a patient had just died of cholera on it. They continued the joke or experiment until the student was actually in the agonies of the dire disease, when in great dismay, they assured him that it was only a joke

and that he had not been exposed at all, but it was without avail, the poor fellow died before them, a terrible confirmation of the theory of the power of the mind over matter.

The hygiene of the different subjects mentioned above will be dwelt upon in detail in the future and let it not be said of Latter-day Israel what the Lord declared concerning ancient Israel, "My people are destroyed for lack of knowledge."[29]

Sofie Herzog

Woman Railroad Surgeon

An eccentric individual with an independent spirit, Dr. Herzog pushed the boundaries of proper societal behavior for women.
INSCRIPTION ON THE TEXAS HISTORICAL COMMISSION
MARKER FOR DR. SOFIE HERZOG, 2018

THE GUNSHOT VICTIM OCCUPYING A ROOM IN DR. SOFIE HERZOG'S office winced in pain while struggling to remain still. His discomfort was not entirely due to the bullet lodged in his abdomen but to the uncomfortable position in which the Brazoria, Texas, physician had him placed. The lower half of the man's body had been raised, with his ankles fashioned to a horizontal pole. The upper portion of his body was flat against the mattress. Dr. Herzog's procedure for removing bullets and buckshot was unconventional but had proven to be successful. It had been her personal experience that probing the wound in search of the bullet with a surgical instrument was detrimental to the patient. If, indeed, she had to do any probing at all, she preferred to use her fingers, but that was only a last resort. After tending to more than a dozen gunshot wounds, the doctor had learned the most effective way to deal with such an injury was to let gravity do the work. When the victim's body was elevated, the bullet often found its way to the surface for easy extraction.[1]

Dr. Herzog's reputation for the treatment of gunshot sufferers spread rapidly throughout the region in the 1890s. Her talents were in constant demand. When she'd removed more than twenty bullets from outlaws

Dr. Sofie Herzog. Courtesy of the Brazoria Heritage Foundation.

and lawmen alike, she had a necklace made from the slugs, with gold links to separate each projectile.[2]

Sofie Deligath was born on February 4, 1846, in Vienna, Austria.[3] The precocious young woman would eventually follow her father's example and pursue a career as a physician. At the age of fourteen, before she had fully realized it was possible for a woman to become a doctor, she married a prominent Viennese physician named August Herzog. Between 1861 and 1880, Sofie gave birth to fifteen children—among them, three sets of twins. She lost eight of her children to various illnesses while they were still infants.[4]

August accepted a position with the Unites States Navy hospital in 1866 and moved his family to New York City. While caring for her home, children, and husband, Sofie decided to study medicine. Training for women in the profession in the States was limited to midwifery. The aspiring doctor not only took advantage of those limited courses but also traveled to Vienna to attend school. In Austria, there was less stigma attached to women learning medicine.[5]

Armed with a certification in midwifery in 1871, Sofie returned to the US and began practicing medicine. She continued her education in the States, receiving a degree in 1894 from the Eclectic Medical College. She worked as both a midwife and physician on the East Coast until her children were grown and her husband had passed away in 1895.[6]

Dr. Herzog traveled west shortly after her husband's passing. The couple's youngest daughter was living in Brazoria, Texas. Sofie decided to make her home and open a practice there after spending time with her daughter, son-in-law, and her grandchildren. She adapted quickly to her new surroundings, which were wild and rustic in comparison to where she had lived and worked in New Jersey. Brazoria was an agricultural town. Sugar and cotton mills provided the bulk of the employment and income for the region. Federal soldiers, northerners, foreign immigrants, Confederate soldiers from Texas and the South, ambitious businessmen, and desperadoes filtered in and out of the location, and many of the disputes that erupted because of combative, unruly individuals were more often than not settled with six-shooters.[7]

Patients without gunshot wounds who couldn't make it into town to see a doctor depended on physicians to travel to them. Dr. Herzog would have to make her way to homesteads and farms across the rugged trails on horseback. Those who objected to a woman being a doctor quickly set their biases aside when they were stricken with pneumonia or needed a broken bone mended. Adorned in a split skirt and black coat with a man's top hat covering her short hair, the fifty-year-old physician visited the sick and hurting in and around Brazoria.[8]

Dr. Herzog was not only the sole female physician in town, but she also served as the pharmacist. She always had ingredients at the ready to mix laxatives, treat malaria, check diarrhea, or help with upset stomachs, migraines, and hemorrhoids. The residents of Brazoria trusted the lady medic and fondly referred to her as Dr. Sofie. She made history in 1897 when she became the first woman to join the South Texas Medical Association. Six years later, she made history again when she became the first woman to be elected vice president of the organization.[9]

In the spring of 1904, the St. Louis, Brownsville and Mexico Railway began work on expanding the line that ran from Brownsville, Texas, to Houston, Texas. Hundreds of railroad employees filtered into the area to survey land and lay track for trains bound for Brazoria and surrounding communities. Dr. Herzog was frequently summoned to tend to the railroad workers along the line who were either sick or injured. Railroad executives soon recognized that a designated physician needed to be added to the payroll, and they offered the job to Sofie. She accepted the position as railroad surgeon, but before she officially began work, she received a telegram from the board of directors of the line. Hiring a woman doctor seemed inappropriate to the railroad executives. They politely offered Sofie a way out, letting her know how understanding they would be if she reconsidered taking the job because it wasn't suitable for a lady. Dr. Herzog responded with a telegram that assured the gentlemen she was up to the task and that her gender wasn't a factor. She let them know she'd only step down if they fired her for not doing the work. No more discussion was had on the subject in the twenty years she was employed with the railroad.[10]

An article about the headstrong and accomplished doctor and her work with the railroad appeared in the January 4, 1910, edition of the *El Paso Herald*. The report reads as follows:

No railroad surgeon in the country is prouder of the title than is Dr. Sophie [*sic*] Herzog of Brazoria, Texas, who is the only woman in the United States to enjoy that distinction. Dr. Herzog has been a practicing physician in this country for nearly twenty years, the formative years of her American career having been spent in New York state. When she moved to Texas, her fame as a surgeon soon spread, and her reputation reached the ears of men backing the construction of the St. Louis, Brownsville & Mexican railroad, and she was employed as the official railroad physician. She has been retained in that capacity ever since.

. . . No matter what time of day or night she is needed, Dr. Herzog leaves her home for the scene of railroad accidents or other trouble. Freight cars, "wildcat" engines, and handcars alike have been her mode of transportation when haste was necessary, for she does not balk at any conveyance when it gets her to her destination in a hurry.[11]

Dr. Sofie Herzog was frequently summoned to tend to the railroad workers along the line who were either sick or injured. Author's collection.

Although Sofie was employed with the railroad, she continued to maintain her own practice. Not only did she treat those suffering with everything from deep cuts to pneumonia, but she was also intent on finding cures for more serious ailments such as smallpox. Her office was in her daughter and son-in-law's home until her son-in-law learned Dr. Herzog was treating people with highly contagious diseases there. He did not want to run the risk of his wife, his children, or himself getting infected, so he asked Sofie to leave. The doctor then opened a clinic near the railroad. The building was large enough for her practice and included an examination room, a waiting room, a pharmacy, and living quarters.[12]

Dr. Herzog's office was unique because, in addition to the usual elements found in a medical practice, the pharmacy area looked more like a mercantile. The doctor had several items on display for sale, such as postcards, lace doilies, walking canes, and tonics she'd made herself. Among the ordinary merchandise was a collection of oddities that sparked Sofie's fascination, such as taxidermy animals, snakeskins, antlers, and bear rugs. She also had an enormous collection of books and invited citizens of Brazoria to borrow any title they wanted at any time.[13]

Dr. Herzog's interests were varied. She ventured into real estate briefly, opening the Jefferson Hotel on October 9, 1908. Her desire to maintain historic burial places led to her supplying the funds to build Brazoria's first Episcopal church and cemetery.[14]

A widely circulated newspaper article about Dr. Herzog's career in January 1911 noted that, in the last ten years, the well-known physician had had many offers of marriage. When the reporter asked for a picture to accompany the published article and told Sofie he was going to mention the proposals she had received, she replied, "If you can find a husband for me, I can support one. He need not do anything except call me 'honey' and 'sugar plum.'"[15]

Dr. Herzog accepted Colonel Marion Huntington's invitation to be his wife in the spring of 1913. Before the pair was married on August 23 of that same year, Sofie had a prenuptial agreement drafted and signed by her future husband. Their marriage certificate is proof that Sofie wanted to maintain her independence after the couple was wed.

She insisted the document read Mr. Marion Huntington and Dr. Sofie Herzog. Sofie was sixty-seven when she married for the second time.[16]

Shortly after Sofie and Marion were wed, she traded her horse and buggy for an automobile. Throughout the duration of her career, she made the rounds to see her patients in a Ford Runabout.[17]

Dr. Sofie Herzog Huntington died of a stroke at a hospital in Houston on July 21, 1925, at the age of seventy-nine. The beloved physician was laid to rest wearing the necklace she had made from the bullets she had extracted from gunfighters in Brazoria.[18]

Gunshot Wounds

The following is an article written by Sofie Herzog, MD, of Brazoria, Texas:

The term "gunshot wound" is applied generally to all injuries inflicted by missilos [*sic*], whatever their character, whose force is derived from the explosive power of gunpowder, but as we have had most to do with those whose caliber range from twenty-two to forty-five, I will only speak of removing and repairing this kind of injuries. I will especially describe what I do when I am called to a person who has been shot and the result of the injury.

The country physicians have many shooting calls, as no-goods shoot every chance they have. Accidental shooting is seldom. When I have arrived, I inquire how the shooting was done, position of the person, distance, Winchester, or pistol. I never probe. I desire that the bullet shall come to me, and I've never failed to get it. I have lived in Brazoria for twenty-two months, and, during this time, I have been called in fifteen times to remove bullets and twice for shot. I got the bullet out every time and never lost a case.

I first insert my finger in the entrance made by the bullet with forward motion in the direction which the bullet had taken, and I nearly always find it this way, because wherever the bullet goes there is pain. The principal thing is to know the position of the patient when the bullet entered the body. I do not touch the wound, and if I cannot find the bullet with my finger, if possible, I wait. I put the patient on the side corresponding to the entrance of the wound, and in this way, I never fail to get it because the heavy weight of the bullet gravitates to the wound entrance. If the bullet entered the abdomen, I put the patient in a hanging position so that the back is upwards, and the bullet will, by its own weight, come out this way. I had two calls of this kind—one, that of a twenty-two and in the other a thirty-eight caliber. The first, a boy fourteen years old, shot himself while cleaning a pistol. The bullet entered the abdomen half an inch below the umbilicus. I was called one hour later, after another doctor had failed to locate the bullet. There was slight hemorrhage. I closed the wound with absorbing cotton, then put the patient in a hanging position, two inches above the bed. Twenty-four hours later, I removed the cotton with a quick pull, and the bullet fell out with the cotton. The boy was well in one week.

The other case was that of a man twenty-eight years old. He was shot in the abdomen one and a half inches to the left of the umbilicus. I treated him the same way as I did the boy, and, the next day, I removed the bullet without trouble.

To see if my treatments were right, I probed the third call of this kind which I had with the "Feuhrer" probe. I could feel the bullet, but, when I went to remove it, the bullet slipped out of the way, and I failed to get it. The man died. I made an incision where the bullet had gone to see where it stopped, and I found that it had been pushed out of the way by the probe.

The repair of the gunshot wound is often disturbed by foreign matter, such as [a] portion of clothing, gun wadding, etc. Severe hemorrhage seldom occurs, especially, as arteries and veins are not injured because of their nonresistance and elasticity; they are frequently pushed aside. There is one thing I want to say—if ever you have to deal with shot wounds, abdominal, never let the bowels come out, as your patient may be lost. I have had severe cases, but all were out on the twelfth day. If you come to Brazoria, I will show you my seventeen men who are well and ready to shoot as well as to be shot at any time.

My treatment is, after I know the location of the bullet, to give hypodermatic [sic] injections of cocaine. I make the incision according to the hole in the skin. Never make a long incision in the face or neck—always make it according to the wrinkles and folds, because the wound heals quicker, it prevents scars, while it will not be so disagreeable and looks better. After the removal of the bullet, I make one or two stitches, fill the cavity with acetanilide, cover with absorbing cotton, and bandage the wound up. I do the same with the wound of entrance; after three days, I remove the dressing and close only the entrance; the exit I leave open, but dust with acetanilide.[19]

Helen MacKnight Doyle

The Resolute Doctor

Taken as a whole they [women] will probably never amount to much unless the experience of the past belies that of the future.
PHYSICIAN AND GUEST SPEAKER AT TOLAND HALL MEDICAL
SCHOOL ABOUT WOMEN IN MEDICINE, 1875

EIGHTEEN-YEAR-OLD NELLIE MATTIE MACKNIGHT STEPPED CONFI-
dently into the spacious examination room at San Francisco's Toland
Hall Medical School. Thirty-five male students stationed around cadav-
ers spread out on rough board tables turned to watch the bold young
woman enter. The smell of decomposing corpses mixed with the tobacco
smoke wafting out of the pipes some of the students were puffing on, and
it assaulted Helen's senses. Her knees weakened a bit as she strode over
to her appointed area while carrying a stack of books and a soft rawhide
case filled with operating tools.[1]

To her fellow students, Nellie was a delicate female with no busi-
ness studying medicine. Determined to prove them wrong, she stood up
straight, opened her copy of *Gray's Anatomy*, and removed the medical
instruments from the case.[2]

It was the spring of 1891. She nodded politely at the future doctors
glowering at her. A tall, dapper, bespectacled professor stood at the front
of the classroom, watching Nellie's every move. The sour expression on
his face showed his disdain for a woman's invasion into this masculine
territory. The assignment the students were required to complete within

Dr. Helen MacKnight Doyle. California State Library.

an hour was the dissection of male cadavers' heads, upper torsos, and pelvic regions. The part of the body Nellie was given to dissect was the pelvis. She studied the corpse lying before her, then nervously flipped through her anatomy textbook.[3]

The students at the other operating tables around her were busy cutting and slicing, but Nellie couldn't bring herself to pick up a scalpel. The annoyed instructor strode over to her, his brows furrowed. "Do you expect to graduate in medicine or are you just playing around?" he snarled. "I hope to graduate," Nellie responded in a small voice.[4] All eyes turned to watch the exchange between the professor and the first year student.

"If you have feelings of delicacy in this matter, young woman," the professor chided, "you had better leave college and take them with you or fold them away in your work basket and be here on your work stool tomorrow morning. We don't put up with hysterical feminine nonsense in men's medical school."[5]

Nellie bit her tongue and held back the tears. She clenched her fists to her side, and as the instructor walked away, she whispered to herself, "I will graduate, and that's a promise."[6]

As far back as Nellie could remember, she'd always had a resolute spirit. Born on December 15, 1873, in Petrolia, Pennsylvania, to Olive and Smith MacKnight, the young woman had endured tragedies that left her struggling to make it through the childhood years with any ambition at all. Nellie was one of three children. Her parents' son and first daughter had died shortly after they were born. Olive was overly protective of her surviving child, and Smith, a land surveyor by trade, showered the little girl with attention. Nellie lacked for nothing until she was five years old, when Smith decided to travel west in search of gold. Intent on making the journey alone, he sold the home he shared with Olive and his daughter and sent the pair to live with his parents in upstate New York.[7]

By the time Smith's first letter from California arrived, Nellie and her mother had settled into life on the MacKnight farm. Smith's absence made Olive quiet, withdrawn, and despondent. Outside of her daughter, she seemed content to be left alone. Nellie, on the other hand, was outgoing and cheerful. She was particularly close to her grandmother, whose character was much like her own. Grandmother MacKnight taught

Nellie how to cook and quilt and how to prepare homemade remedies for certain illnesses. Her grandfather and uncle taught her how to ride a horse and care for animals.[8]

As Olive slipped further into depression, Nellie became more attached to her grandparents. Smith's letter announcing that he had purchased a mine with "great potential" momentarily lifted Olive's spirits and gave her hope they might be together soon.[9] Several days later, another letter from Smith arrived informing Olive that he would have to wait for the mine to pay off before he could send for her and Nellie. The news devastated Olive. The dispirited woman nightly cried herself to sleep.[10]

The stability Nellie had come to know at her grandparents' home ended abruptly one evening in October 1880. Her grandmother contracted typhoid fever and died after a month of suffering with the illness. Nellie watched pallbearers carry her grandmother's wooden coffin into the cemetery. She wept bitterly, wishing there had been something she could have done to save her. The subsequent death of her favorite uncle, suffering from the same ailment, served as a catalyst for her interest in healing.[11]

Fearing for the physical well-being of her daughter, Olive moved Nellie to her father's home in Madrid, Pennsylvania. Any hopes the two had that their circumstances would improve at their new location were dashed when Olive became sick and collapsed. She was suffering from typhoid fever, and her elevated temperature had made her delirious. She didn't recognize her surroundings, her family, or her child, and she cried out constantly for her husband.[12]

Olive recovered after several weeks, but the fever and the sadness of being separated from Smith had taken its toll. Her dark hair had turned gray, and the dark hollows under her eyes were a permanent fixture.[13]

Smith's mine in Bodie, California, had still not yielded any gold, and he was unable to send any money home to support his family. To keep herself and Nellie fed and clothed, Olive took a job at the Warner Brothers Coraline Corset Factory. Nellie attended school and excelled in all her subjects, showing an early aptitude in medicine. She pored over books on health and the human body.[14]

When Nellie wasn't studying, she spent time trying to lift her mother's melancholy disposition. Letters from Smith made Olive even more anxious to see her husband again and even more brokenhearted about having to wait for that day to come. She began using laudanum, a tincture of opium used as a drug, to ease the pains she had in her hands and neck. The pains in her joints were a lingering effect of the typhoid fever. Olive developed a dependence on the drug, and one evening, she overdosed. She left behind a note for her daughter that read as follows: "Be a brave girl. Do not cry for Mamma."[15] Smith was informed of his wife's death, and although he was sad about the loss, he opted to continue working his claim.

The day after Olive was laid to rest, ten-year-old Nellie was sent back to New York to live with her father's brother and his wife. Nellie's uncle was kind and agreeable, but her aunt was not. She was resentful of Nellie being in the home and treated her badly. Nellie endured her aunt's verbal and physical abuse for two years, until her mother's sister invited Nellie to live with her at her farm four miles away.[16]

Nellie adapted nicely to the congenial atmosphere and learned a great deal about primitive medicine from her aunt. After a brief time with her aunt, Nellie finally received word from her father. Smith was now living in Inyo County, California, and working as an assayer and surveyor. Nine years of searching for gold had turned up nothing. Smith decided to return to land surveying, and he wanted his daughter by his side.[17]

Fourteen-year-old Nellie met her father on the train in Winnemucca, Nevada. Smith had agreed to meet with her there and escort her the rest of the way to his home. Although his face was covered with a beard and his eyes looked older, Nellie knew her father when she saw him. Smith, however, did not instantly recognize his child. He wept tears of joy as she approached him. "You're so grown up!" he told her.[18] Little time was spent before the two were made to take their seats to continue their journey. Father and daughter had a long way to travel before they reached Smith's cabin in Inyo County. As the train sped along the tracks, Nellie was in awe of the purple blossoming alfalfa that grew along the route and of the grandeur of the Sierra Mountains.[19]

Nellie continued to be impressed with the sights and people she encountered during their two-day trip to the homestead in Bishop. Smith promised his daughter a happy life among the beauty and splendor of the California foothills. Nellie recalled in her journal how exciting, cheery, and carefree she found her new home to be. "The streets of the town were like a country road," she wrote, "lined with tall poplars and spreading cottonwoods—quick growing trees marked boundary lines and gave shelter to man and beast. Their leaves were pieces of gold in the sunshine."[20]

After a brief stay at her father's ranch, Smith enrolled Nellie at the Inyo Academy. She would be studying and living at the school. Smith spent a great deal of time on surveying trips and wanted Nellie to be in a safe place while he was gone. The Inyo Academy was home to many young men and women whose parents were ranchers and cattlemen from all over the country. Nellie thrived at the school and, once again, excelled in every subject. She was valedictorian of her class when she graduated from the academy.[21]

Smith insisted the now-seventeen-year-old Nellie should go to college and continue her education. She was in favor of the idea and initially decided to pursue studies in literature. Smith promised to pay for her schooling only if she chose law or medicine as her point of interest. "If I wished an education I must abide by his decision," Nellie noted later in her memoirs. "My only knowledge of the law was of 'the quality of mercy.' My only picture of a woman doctor was that of Dr. Mary Walker, dressed in men's clothes and endeavoring in every way to disguise the fact that she had been born a woman. That I should choose neither was unthinkable."[22]

As Nellie contemplated her decision, her thoughts settled on her grandmother's struggle with typhoid fever and her mother's fatal attempt to ease the physical pain she suffered. It didn't take Nellie long to recall her early interest in the profession and conclude that her calling was in medicine.[23]

Just prior to Nellie graduating from the academy, her father had remarried. Nellie's initial reaction to her stepmother was one of indifference, but as she got to know her, she had a change of heart. She was an

extremely kind woman and never failed to show Nellie love and compassion. She encouraged her stepdaughter in her future endeavors and cried for days when Nellie moved to San Francisco to attend medical school.[24]

Smith accompanied his only child to the Bay Area and onto the campus of Toland Hall Medical College. He paid her tuition, helped her find a place to live, wished her well, and returned to Bishop. Their parting was difficult. Nellie was grateful for the opportunity he was giving her and vowed to be home soon with a diploma in hand. Neither fully realized how difficult it would be to fulfill that promise.[25]

The attitude of the majority of Toland Hall's professors and students toward women in medicine was vicious. Most felt a female presence in the medical profession was a joke. Nellie was aware of the prevailing attitude and was determined to prove them wrong. She devoted herself to her studies, arriving at school at dawn to work in the lab. She kept late hours poring over her anatomy books and memorizing the definitions of various medical terms.[26]

The harder she worked, the more resentful her male counterparts became. Classmates exchanged vulgar jokes with one another whenever the women were around in hopes of breaking their spirits. Professors were cold and distant to Nellie and the other two women at the school, often refusing to answer their questions. Dr. R. Beverly Cole, Toland Hall's professor of obstetrics and gynecology, delighted in insulting female students during his lectures. He maintained publicly that female doctors were failures. "It is a fact," he told students, "[that] there are six to eight ounces less brain matter in the female, which shows how handicapped she is!"[27] Nellie quietly tolerated Dr. Cole's remarks and allowed them only to spur her on toward the goal of acquiring a degree.

While in her third year of medical school, Nellie took an intern position at a children's hospital. Many of the patients that allowed her to care for them were Chinese. She assisted in many minor operations and births and helped introduce modern forms of cures that countered the Far East's approach to handling illnesses.[28]

Months before Nellie was to graduate, she was granted permission to assist in a major surgery. Two physicians were required to perform an emergency mastoid operation on a deathly ill dock worker. Nellie was one

of two interns on duty and the only woman. The male intern fainted at the site of the first incision. Nellie was a bit uneasy as well but assured the doctor she could do the job when he ordered her at his side.[29]

"The surgeon talked as he worked," she recalled years later. "He described the blood supply, the nerve supply, the vessels that must be avoided, the paralysis that would follow if he invaded the sacred precincts of the facial nerve. Chip by chip he removed the bone cells, but the gruesome spectacle had been magically transformed into a thrilling adventure. I forgot that I had a stomach; forgot everything but the miracle that was being performed before my eyes, until the last stitches were placed, the last dressings applied."[30]

Nellie eagerly looked forward to graduation day. Although her grades were good and her talent for medicine was evident, the male faculty and students remained unimpressed with her efforts. She was confident that when she and the two other female students accepted their diplomas, the men would be forced to recognize that a woman's place in the emerging profession was definite.[31]

Shortly after passing her final examination, Nellie was summoned to the dean's office. He was a man who did not share Nellie's vision for a woman's role in medicine, and because of that, she feared he was going to keep her from graduating. The matter he wanted to discuss was how she wanted her name to appear on the diploma. She told the dean that her christened name would be fine. The man was displeased. "Nellie Mattie MacKnight?" he asked her in a mocking tone. "Nellie Mattie— Nellie Mattie?" Nellie did not know how to respond. "How do women ever expect to get any place in medicine when they are labeled with pet names?" he added.[32]

The dean persuaded Nellie to select a more suitable name. She searched her mind for the names in which her name had been derived. "I had an Aunt Ellen . . . [and t]here was Helen of Troy," she thought aloud. "You may write Helen M. MacKnight," she said after a moment of contemplation.[33] The dean informed her that he would make the necessary arrangements. Before she left his office, he added, "See that it is Helen M. MacKnight on your shingle, too!"[34]

Nellie graduated with honors from Toland Hall Medical School. Her father and stepmother were on hand to witness the momentous event. As her name was read and the parchment roll was placed in her hands, she thought of her mother and grandmother and pledged to help cure the sick. Chances for women to serve the public in that capacity were limited, however.[35] Widely circulated medical journals stating how "doubtful it was that women could accomplish any good in medicine" kept women doctors from being hired.[36] They criticized women for wanting to "leave their position as a wife and mother" and warned the public of the physical problems that would keep women from being professionals.[37] "Obviously, there are many vocations in life which women cannot follow; more than this, there are many psychological phenomena connected with ovulation, menstruation and parturition which preclude service in various directions," read an article in the 1895 edition of the Pacific Medical Journal. "One of those directions is medicine."[38]

In San Francisco in 1883, there was only one hospital for women physicians to practice medicine. The Pacific Dispensary for Women and Children was founded by three female doctors in 1875. The facility was designed to provide internships for women graduates in medicine and training for women in nursing and like professions. Nellie joined the Pacific Dispensary staff, adding her name to the extensive list of women doctors already working there from all over the world.[39]

In the beginning Dr. MacKnight's duties were to make patient rounds and keep up the medical charts by recording temperatures, pulses, and respirations. After a brief time, she went on to deal primarily with children suffering from tuberculosis. She also assisted in surgeries and obstetrics, and participated in diphtheria research.[40]

In 1895 Nellie left the hospital and returned home to help take care of her ill stepmother. Within a month of arriving at her parents', her stepmother was on her way to a full recovery. Nellie decided to stay in Bishop and establish her own practice. She set up an office in the front room of the house where she lived, stocked a medicine cabinet with the necessary supplies, and proudly hung out a shingle that read "Helen M. MacKnight, M.D., Physician and Surgeon."[41]

Dr. MacKnight traveled by a horse-drawn cart to the homes of the handful of patients who sought her services. She stitched up knife wounds, dressed severe burns, and helped deliver babies. As news of her healing talents spread, her clientele increased. Soon she was summoned to mining camps around the area to treat typhoid patients. Although her diploma and shingle read "Helen M. MacKnight," friends and neighbors who had known her for years called her "Doctor Nellie."[42] It became a name the whole countryside knew and trusted.

While tending to a patient in Silver Peak, Nevada, Nellie met a fellow doctor named Guy Doyle. The physicians conferred on a case involving a young expectant teenager. Dr. Doyle treated Dr. MacKnight with respect and kindness. Nellie was pleasantly surprised by his behavior. "I had worked so long fighting my way against the criticism and scorn of the other physicians of the area, that it seemed a wonderful thing to find a man who believed in me and was willing to work with me to the common end of the greatest good to the patient," she recalled years later about their meeting.[43]

What began as a professional relationship grew quickly into a romantic one. The couple decided to pool their resources and go into business together. They opened an office inside a drugstore on the main street of Bishop. In June 1898, Helen and Guy exchanged vows in a ceremony that was attended by a select few in Inyo County.[44]

Dr. Nellie MacKnight Doyle and Dr. Guy Doyle provided the county with quality medical care for more than twenty years. The couple grew their practice and took care of generations of Bishop residents.[45] Nellie and Guy had two children, a girl and a boy. When their daughter grew up, she decided to follow in her mother's footsteps and pursue a medical degree. Upon her graduation from college, she was offered a foreign fellowship in bacteriology.[46]

Dr. Nellie M. MacKnight spent the last thirty years of her life studying and practicing anesthesiology.[47] She died in San Francisco on July 22, 1957, at the age of eighty-three.[48]

The Treatment of Typhoid Fever

In November 1879, W. M. Jenner published the following article in The Lancet Medical Journal, *volume 114, issue 2933; she built her work on that of Dr. MacKnight Doyle.*

In so complex a disease as typhoid fever the mortality and symptoms of which vary not only with the age, habits, and family constitution of the patients, but also with the dose and mode of access to the system of the poison, the conditions which precede and those which accompany the disease during its incubative period. Also important to consider in this matter is the earliest development of the disease, the epidemic constitution, the date at which the disease is first treated, and the early management of the patient. It is scarcely possible to find two cases in all respects identical, and quite impossible to collect records of a sufficient number of cases practically identical to determine by numerical analysis the best mode of treatment. And even of the specially prominent symptoms—e.g., temperature, rapidity of pulse, diarrhea—each one may owe its origin to such different pathological conditions. It is so often impossible to determine in any given case to which of these several conditions it is due, that in the present state of pathological knowledge it seems to me that it is impracticable to determine otherwise than by the opinions formed by individuals from personal experience, what are the best means to be employed in the treatment, not only of typhoid fever itself, but also of each symptom, and how and under what circumstances each remedy should be employed.

I do not in the least degree under-estimate the immense importance of numerical analysis for arriving at truth on medical subjects; and if it were possible to find the value of the several remedies proposed for the treatment of typhoid fever, or of its symptoms, by numerical analysis, the results of such an analysis would be real steps in our knowledge, for facts would replace opinions, and doubts in regard to the influence of remedies be impossible. Each special act of treatment would then be based on firm grounds, instead of being, as it now is, an experiment performed by the medical attendant. The sum of his own experiments constitutes each man's experience, to which, in proof of the correctness of his practice, he appeals as to a judge whose decision is final and infallible. And yet how

different are the conclusions, all based on experience, drawn by different observers in regard to the effects on any given disease or symptom of any given remedy.

The physician orders a drug or stimulant, or employs a bath; and then, according to the credulous or skeptical tendency of his mind, his experience in the special disease he is treating, his knowledge of its natural course and history, his powers of observation, and the general soundness of his judgement, the post hoc is, in his opinion, a mere post hoc [after the fact], or a veritable propter hoc [because of this]; and the remedies he employed have been, in his opinion, of little consequence, or all-important; and so he builds up his experience on treatment. And the difficulty of building up treatment by the accumulation of the experience of many men, expressed in their opinions merely, is enhanced by the fact that, even when the conclusion is correct, the good effect following the administration of the drug is a veritable propter hoc.

It is for many doctors an impossibility to follow or define for themselves, much more describe to others, the several steps in the mental analysis of the facts before them they have performed in arriving at their correct conclusion. Some doctors appear to be capable of performing this delicate mental analysis correctly without being able to follow the steps of the analysis in their own minds; they are no more capable of following their own mental efforts, or telling another how they arrived at their correct conclusion, than are those children who solve complex arithmetical problems in a few seconds without themselves knowing by what steps they pass from the premises to the conclusion.

Believing, however, notwithstanding, all these sources of serious error, that in the present state of pathological knowledge it is impossible to fix the treatment of typhoid fever on a more sure basis than individual opinions founded on experience, I propose to describe what my experience has taught me to be the most successful methods of treatment of the disease, and also some of the symptoms which by the severity they may attain cause grave discomfort to the patient, or place his life in danger. I shall limit myself to those symptoms which may be considered to be the natural manifestations of the disease, for time will not permit me to pass even briefly in review all the symptoms common in the disease or the complications, although the patient often succumbs to these symptoms and to these complications.

To give a clear view of the treatment of these symptoms, I shall be obliged to refer to the pathological conditions in which they severally originate.

I have never known a case of typhoid fever cut short by any remedial agent—that is cured. The poison which produces any one of the acute specific diseases (to which order typhoid fever as much as smallpox belongs) having entered the system, all the stages of the disease must, so far as we know, be passed through before the recipient of the poison can be well. If the patient can be kept alive for a definite time the specific disease ends, and then, if no local lesion remains to constitute a substantive disease, the patient is well. The treatment of typhoid fever is essentially rational. To treat a case with the best possible prospect of success the physician ought to be acquainted with the epidemic constitution of the period, the etiology of the disease, its mode of attack, its natural course, the order of appearance, and the natural duration of each of its symptoms, the way in which each symptom influences the termination, the several pathological lesions which produce or may produce each special symptom, and the complications to be watched for at each stage of the disease.

Certain facts have to be kept in mind when treating a case of typhoid fever, and when estimating the effect of remedies: First, that the disease, in the majority of cases at least, is produced by the action of a small portion of the excreta from the bowel of a person suffering from typhoid fever; that air from a drain, or air blowing over dried feculent matter, may convey the poison to the patient, or his own fingers may carry it to his mouth, or that the vehicle for the poison may be a fluid—for example, water or milk; and that the poisonous properties of the excreta may be destroyed by boiling the fluid in which they are contained, though not by filtering the fluid. Secondly, that the natural duration of a well-developed case of typhoid fever is from twenty-eight to thirty days. Hence subsidence of the fever before that date should be regarded with suspicion, and the patient not treated as if the specific disease had ended, while the continuance of febrile disturbance after that date should lead to repeated and most careful examination of the patient, in order to ascertain if any local lesion is keeping up the febrile excitement. But not only is the duration of the specific disease limited, but the prominent symptoms have their regular order of sequence, and several their own natural limits of duration—that is, a time to begin and a time to end; and the natural termination of a symptom has often been attributed to the remedial agent last employed.[49]

Elizabeth McDonald Watson

Soldier of the Living

Many is the Californian living today whose mother traveled a long distance to Nevada City because she had heard that a baby could be born at Miss Watson's spic-and-span hospital in safety.

THE UNION NEWSPAPER, APRIL 6, 1951

THE SKY OVER NORTH SAN JUAN, CALIFORNIA, ON APRIL 10, 1904, WAS gravel gray. Large storm clouds had formed, blotting out the ash color of the sun. Anyone caught on the main thoroughfare of the small gold mining town when the rain began to fall scurried for cover. The wheels on the horse-drawn buggy traveling fast through the downpour rolled over puddles and patches of mud before coming to a stop in front of the Bradbury Hotel. Carrying a black, weathered medical bag, thirty-nine-year-old Elizabeth McDonald Watson leapt out of the vehicle and raced into the building. The Bradbury family, for whom the hotel was named, was suffering with a bacterial disease known as diphtheria. Two family members had already died from the illness, and without medical attention, the others were destined for the same fate.[1]

There weren't any doctors in North San Juan to call on the sick. The ailing relied on the help of the one woman in the area with nurse's training. Elizabeth had been nursing patients for more than twenty years prior to her arrival in Nevada County, California. Her practical experience in medicine combined with her willingness to travel wherever her services were needed had earned her the trust of everyone in the area. She read

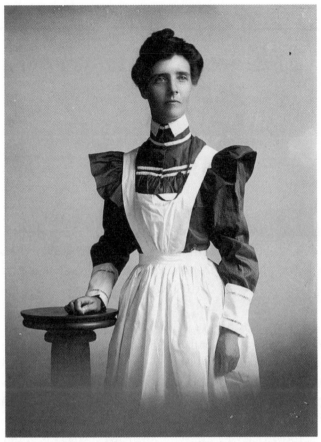

Nurse Watson's graduation portrait. Searls Historical Library GP-0832.

every book and article available on medicine and familiarized herself with afflictions and disorders from burns and rashes to measles and diphtheria. Elizabeth knew from the medical journals she'd acquired in 1890 that it was discovered that serum made from the blood of immunized animals contained an antitoxin that, when injected, cured diphtheria. Elizabeth had managed to get doses of the serum to administer to people who had the disease. The Bradbury family's health improved after Nurse Watson gave them their shots, and she stayed with them until they were fully recovered.[2]

Born on October 13, 1865, in Durris, Kincardineshire, Scotland, to Catherine and Alexander Watson, Elizabeth never knew a time when she didn't want to be a nurse. She left home at eighteen to attend school to learn about medicine and get a degree in the field she had dreamed of since childhood. No sooner had her studies begun when she was called home to help care for her mother, brothers, and her father, who had become ill. Alexander died in 1896, and the following year, Elizabeth traveled to the United States to be with her brother John, who was in a hospital in Detroit, Michigan. John was a twenty-five-year-old carpenter who had contracted a disease of the spine. He passed away on January 25, 1897.[3]

Elizabeth decided to go west after her brother's death. She settled in eastern Idaho, where she took a job teaching school at the Lemhi Indian Agency. In addition to educating children, she assisted a local physician with his practice. As a nurse in training, she continued to learn more about medicine. It reignited her passion to pursue a career in the profession.[4]

Elizabeth made several friends while working at the agency, including Dr. Herbert Dudley and his wife and family. Both Elizabeth and Dr. Dudley left Idaho in early 1899. The doctor relocated to Nome, Alaska, and Elizabeth moved to Butte, Montana. The two corresponded often. Dudley shared with Elizabeth that while en route to Alaska, he had stopped to visit a colleague in a scenic town in Northern California called Nevada City. His description of the area was so complimentary that she was convinced she had to see it for herself. Elizabeth traveled by train to the area in late December 1899 and arrived in Nevada City on January 2, 1900.[5]

Elizabeth was captivated by the mining town. The beautiful Sierra Mountain range that surrounded the community, the magnificent oak and pine trees that reached to the sky, the quaint houses, and the generous people led her to believe she had moved to the most idyllic spot in the state. Fortunately for Elizabeth, Nevada County was in desperate need of nurses and doctors. She was called on to help tend to employees at the Empire Mine (the largest and richest mining operation in the West), logging companies, poultry farms, and ranches. When she wasn't

working, she was focused on the nursing correspondence courses she was taking from the Chautauqua School in New York. She received her long-awaited diploma in 1905.[6]

Although Elizabeth was content with working as a private nurse, she recognized the county needed a hospital, and she was determined to see that residents had one. In 1910 she and another practicing nurse named Laura Mary Peterson opened the Nevada City Sanitarium. The modest medical facility had eight rooms for patients, a well-equipped operating room, a reception area, and a dining hall. The location of the sanitarium was conducive to patients requiring long periods of rest. The half acre where the sanitarium was located featured manicured lawns, shade trees, and an abundance of flowers. As the demand grew, so did the hospital, and by 1920, a new wing was added to the building and was supplied with every convenience for the sick.[7]

For more than ten years, Elizabeth's sanitarium was the only hospital in the county. Miners injured in explosions, wranglers kicked by horses, men and women hurt in automobile accidents, expectant mothers, and citizens who contracted the flu during the epidemic of 1918 were treated at the facility. The sanitarium attracted both patients and doctors within a fifty-mile radius. Physicians attending to patients at the hospital were impressed with the efficiency with which Elizabeth ran the business and the attention paid to cleanliness.[8]

There were many times when the hospital was filled to capacity, but that didn't mean anyone needing help was turned away. Babies were delivered in the hallways, and children who had to have stitches or broken bones set were tended to in Elizabeth's personal office. She was patient with those who could only pay their bills a little at a time and forgiving of those who had no money to pay at all.[9]

The Nevada City Sanitarium closed in 1946. After thirty-six years in business, Elizabeth decided it was time to retire. It was estimated that approximately three thousand children had been born at the hospital since it opened its doors. Besides births, there had been thousands of patients with ailments ranging from slight injuries and major illnesses to major surgeries. "In announcing my retirement at this time, I wish to take the opportunity of thanking, on behalf of the staff and myself, our

many friends in Nevada and surrounding counties for their kind and loyal support," Nurse Watson told a local newspaper reporter.[10]

The beloved health provider was the recipient of an outpouring of affection when the community learned she was leaving the job. For more than a month, letters from former patients expressing their gratitude for Elizabeth's work were printed in the Grass Valley, California, newspaper *The Union*.[11]

"Dear Sir," one of the letters about Elizabeth sent to the paper began.

Elizabeth MacDonald [*sic*] Watson—I am one of your 3,000 or more mothers who salute you in this, your birthday. There are very few who would have had the fortitude and courage to do the many good and noble deeds which have been your daily routine of life. The grand noble spirit of service, which has called for far more than the line of duty has found a great and noble woman always on the fighting line of life, and each one who has had the privilege to enter your door has gone forth with a better understanding of the real call of a nurse and a friend.

I was one of the many who were taken to you in the labor of birth. There was no room ready, but you, grand soldier of the living, helped me through hours of pain and gave of your boundless motherlove to my small daughter, and a part of your noble soul to carry through all my life.

Six years later, I stood by the side of my child when her life was on the scales of life or death. Your steady hand and faithful care helped keep my baby here. Only one who has had to stand by the side of a dearly loved on[e] and heard Dr. March say there may be a chance and has accepted "Thy will be done, Oh, God, not mine," can realize the courage and faith of you, Elizabeth MacDonald [*sic*] Watson, standing like a promise of hope by a surgery table.

The silver dollar you have given to each one of your babies has been quite a material item alone. My daughter had her small bank account started as you requested. And this year she has decided to take her training necessary to care for the small helpless folk who come. I am very happy in her choice of her chosen work, and, perhaps when weary hours of fatigue make the going rough, she may remember a small hospital of hope nestled in a spot of beauty in the hills, and your

memory may be a beacon of hope. For the love we give we receive back in thanks.[12]

Elizabeth retired from the sanitarium but continued working as a nurse at the facility, which was transformed into a rest home. Among the people she cared for was her business partner, Nurse Peterson. Elizabeth's nephew Alec Watson, a veteran with the Scottish forces in France during World War I, worked for his aunt by maintaining the property inside and out.[13]

Elizabeth passed away on January 3, 1957, at her home in Nevada City. Her obituary read in part, "[She] was beloved to all for great humanitarian work and unselfish interest in the community . . . and its people . . . Her affection for Nevada City and Nevada County . . . gave her a deep feeling for the needs of the people here, and she kept her hospital for local patients almost exclusively."[14]

Nurse Watson was ninety-one when she died.

Nurse Watson's Medical Recipes

Physicians and nurses in rural areas were general practitioners by necessity. They delivered babies, set broken limbs, pulled teeth, and tended to all sorts of wounds and diseases. They often created their own medications. Such was the case with Nurse Elizabeth Watson. The following are a few of the recipes for medications she'd made herself:

Cough Syrup

½ Ounce Boneset
1 Ounce Digitalis
¾ Pint Water

Heat mixture and bring to a boil the [*sic*] dissolve and add.

2 Tablespoons of Molasses
3 Ounces of Potassium Citrate

Smelling Salts

1 Ounce Potassium Carbonate
½ Ounce Ammonium Carbonate
3 Ounces Sachet Powder

Mix together with small amount of Liqueur.

Tooth Powder

1 Pound Precipitated Chalk
1 Ounce White Castile Soap
2 Ounces Florentine Orris
1 Ounce Sugar
¼ Ounce Oil of Wintergreen or 2 Ounces of Cinnamon

Digestion Aid

 2 Drams of Potassium Acetate
 1 Dram of Potassium Nitrate
 11 Fluid Ounces Spirit of Juniper
 4 Fluid Ounces Peppermint Water

Mix thoroughly.

A teaspoon twice a day together with an occasional aperient at night.[15]

Notes

Introduction

1. *Gunn's Domestic Medicine, Or Poor Man's Friend, Shewing the Diseases of Men, Women, and Children Expressly Intended for the Benefit of Families* (Knoxville: University of Tennessee Press, 1830), 208–211; *Fayetteville Semi-Weekly Observer* (Fayetteville, NC), February 16, 1857.

2. https://www.legendsofamerica.com/diseases-death-overland-trails; "Doctors of the Old West," *Journal of Midwifery & Women's Health* 54 (September 2009): 13–19.

3. Cathy Luchetti, *Medicine Women: The Story of Early-American Women Doctors* (New York: Crown Publishers, 1998), 60–61, 79–80; Vicky D. Burgess, *Ellis Shipp: Sister Saints* (Provo, UT: Brigham Young University Press, 1978), 14–16.

4. *Physicians & Medicine in Early Lowell, Doctors of the Old West*, University of Massachusetts Library, Amherst, MA, Historical records, hanging file, 158.

5. https://www.ancestry.com/Maria M. Dean; *The Independent Record*, August 11, 1918.

6. *The Independent Record*, August 11, 1918.

7. Helen M. Doyle, *Doctor Nellie: The Autobiography of Dr. Helen Macknight Doyle* (Mammoth Lakes, CA: Genny Smith Books, 1983), 15–18.

8. K. A. Anadiotis, *Great Lives in Colorado History: Justina Ford: Baby Doctor* (Palmer Lake, CO: Filter Press, 2013), 15–17; *The Denver Star*, August 12, 1915.

Jenny Murphy

1. *Dr. Jenny Murphy F453*, Yankton County Historical Society, Pierre, SD, historical records.

2. Ibid.

3. Ibid.

4. Robert F. Karolevitz, *Doctors of the Old West: A Pictorial History of Medicine on the Frontier* (New York: Bonanza Books, 1967), 155–56.

5. *Dr. Jenny Murphy*, Yankton Historical Society.

6. Ibid.

7. Ibid.

8. Ibid.

9. Ibid.; *Rapid City Journal*, January 13, 2013.

10. *Dr. Jenny Murphy*, Yankton Historical Society.
11. Ibid.
12. Ibid.
13. Ibid.
14. *Argus Leader*, October 21, 1951.
15. Ibid.
16. Ibid.
17. *Dr. Jenny Murphy*, Yankton Historical Society.
18. Ibid.
19. *Argus Leader*, October 21, 1951.
20. Ibid.
21. Ibid.
22. National Board of Health Bulletin, 1901, National Archives Public Health Services, 1912–1968.

LILLIAN HEATH

1. Thomas Maghee, "The Case of Reconstructive Surgery of the Face," *Colorado Medicine Journal*, 17–18 (March 1920).
2. Ibid.
3. Ibid.
4. Ibid.
5. Ibid.
6. Heath, Lillian, oral history interview by Helen Hubert, American Heritage Center, University of Wyoming, January 6, 1961.
7. Ibid.
8. Ibid.
9. Ibid.
10. Ibid.
11. *The News*, Frederick, MD, May 13, 1950.
12. Ibid.
13. *The Daily Sentinel*, Grand Junction, CO, August 30, 1955.
14. Maghee, "The Case of Reconstructive Surgery of the Face."

ELIZA COOK

1. *Reno Gazette Journal*, May 5, 1892.
2. *Nevada State Journal*, June 9, 1946.
3. Ibid.; *Reno Gazette Journal*, March 27, 2008.
4. *Nevada State Journal*, June 9, 1946; https://www.cambridge.org/core/journals/medical-history/article/epidemiology-of-puerperal-fever-the-contributions-of-alexander-gordon/C917A91D221BD13CEF6724018B316353.
5. *Reno Gazette Journal*, March 3, 1973; *Nevada State Journal*, June 9, 1946.
6. *Reno Gazette Journal*, March 3, 1973; *Nevada State Journal*, June 9, 1946.

7. *Reno Gazette Journal,* March 3, 1973; *Reno Gazette Journal,* March 27, 2008; *Nevada State Journal,* June 9, 1946.

8. *Nevada State Journal,* June 9, 1946.

9. Ibid.

10. *The Observer,* October 14, 1895.

11. *Reno Gazette Journal,* October 3, 1947; www.ancestry.com/Nevada Death Certificates, 1911–1965 for Eliza Cook.

12. *Medical Gazette,* vol. IX, 1882.

EMMA FRENCH

1. https://www.geni.com/people/Dr.-Emma-French; Maurice Kildare, "Doctor Grandma French," *Frontier Times* 41, no. 4 (July 1967): 14–17.

2. Kildare, "Doctor Grandma French."

3. Juanita Brooks, Emma Lee (Logan, UT: Utah State University Press, 1978), 16–17; https://www.geni.com/people/Dr.-Emma-French; *The Toole Bulletin,* July 17, 1962.

4. *Pittsburgh Sun Telegraph,* July 21, 1940; https://www.geni.com/people/Dr.-Emma-French.

5. https://www.geni.com/people/Dr.-Emma-French; *Pittsburgh Sun Telegraph,* July 21, 1940; Brooks, *Emma Lee,* 17–18.

6. Brooks, *Emma Lee,* 17–18; https://www.geni.com/people/Dr.-Emma-French.

7. Brooks, *Emma Lee,* 18–19.

8. Ibid., 20–21; *The Gaffney Ledger,* September 25, 1923; *Arizona Daily Star,* June 24, 1923; https://www.geni.com/people/Dr.-Emma-French.

9. *The Deseret News,* November 11, 1874; *The Deseret Evening News,* September 27, 1875; Brooks, *Emma Lee,* 32–42.

10. https://www.geni.com/people/Dr.-Emma-French; Brooks, *Emma Lee,* 61–62.

11. *Green Mountain Freeman,* March 23, 1877.

12. Ibid.

13. Ibid.

14. Ibid.

15. Brooks, *Emma Lee,* 90–92; Kildare, "Doctor Grandma French."

16. Brooks, *Emma Lee,* 98–99; *The Southern Standard,* March 8, 1879; *The Salt Lake Herald,* April 10, 1879.

17. *Frontier Times,* June–July 1967; *Arizona Daily Star,* August 20, 1880.

18. *Arizona Daily Star,* August 20, 1880; Kildare, "Doctor Grandma French."

19. Kildare, "Doctor Grandma French."

20. Kildare, "Doctor Grandma French."; Brooks, *Emma Lee,* 101–2.

21. Brooks, *Emma Lee,* 101–2; Kildare, "Doctor Grandma French."

22. Kildare, "Doctor Grandma French."

23. Kildare, "Doctor Grandma French"; Brooks, *Emma Lee,* 101–2.

24. Kildare, "Doctor Grandma French."

25. *Arizona Republic,* September 11, 1891.

26. https://www.geni.com/people/Dr.-Emma-French; Brooks, *Emma Lee,* 101–4.

27. *The St. John's Herald,* November 27, 1897.

28. Brooks, *Emma Lee*, 106–7.

29. *The St. John's Herald*, November 27, 1897.

30. https://www.mayoclinic.org/diseases-conditions/trachoma/symptoms-causes/syc
-20378505.

31. Ibid.

32. Caroline Parker, "Optical Sanitation," *The Indian Medical Gazette* 15, no. 32 (May 27, 1891).

BESSIE EFNER

1. Alfred M. Rehwinkel, *Dr. Bessie: The Life Story and Romance of a Pioneer Lady Doctor on Our Western and the Canadian Frontier* (St. Louis, MO: Concordia Publishing House, 1963), 51–54.

2. Ibid.

3. Ibid.

4. Ibid.

5. Ibid.

6. Rehwinkel, *Dr. Bessie*, 2–5; www.ancestry.com/Dr. Bess Lee Rehwinkel.

7. Rehwinkel, *Dr. Bessie*, 2–5.

8. Ibid.

9. Rehwinkel, *Dr. Bessie*, 5–7.

10. Rehwinkel, *Dr. Bessie*, 5–7.

11. Ibid.

12. Rehwinkel, *Dr. Bessie*, 7–9.

13. Ibid.

14. Ibid.

15. Rehwinkel, *Dr. Bessie*, 10–12.

16. Ibid.

17. Rehwinkel, *Dr. Bessie*, 5, 14–17.

18. Ibid.

19. Rehwinkel, *Dr. Bessie*, 18–20.

20. Ibid.

21. Ibid.

22. Rehwinkel, *Dr. Bessie*, 21–22.

23. Ibid.

24. Rehwinkel, *Dr. Bessie*, 23–24.

25. Ibid.

26. Rehwinkel, *Dr. Bessie*, 22–23.

27. Ibid.

28. Rehwinkel, *Dr. Bessie*, 25–28.

29. Ibid.

30. Rehwinkel, *Dr. Bessie*, 29–31.

31. Ibid.

32. Rehwinkel, *Dr. Bessie*, 30–32.

33. Ibid.

34. Ibid.

35. Rehwinkel, *Dr. Bessie*, 35–37.

36. Rehwinkel, *Dr. Bessie*, 40–42.

37. Ibid.

38. Ibid.

39. Ibid.

40. Rehwinkel, *Dr. Bessie*, 49–51.

41. Rehwinkel, *Dr. Bessie*, 37–39.

42. Rehwinkel, *Dr. Bessie*, 39–40.

43. Ibid.

44. Rehwinkel, *Dr. Bessie*, 56–58.

45. Ibid.

46. Rehwinkel, *Dr. Bessie*, 66–68.

47. Ibid.

48. Ibid.

49. Rehwinkel, *Dr. Bessie*, 68–70.

50. Rehwinkel, *Dr. Bessie*, 76–77.

51. Rehwinkel, *Dr. Bessie*, 79–81.

52. Ibid.

53. Rehwinkel, *Dr. Bessie*, 83–86.

54. Rehwinkel, *Dr. Bessie*, 92–93.

55. Rehwinkel, *Dr. Bessie*, 162.

56. Rehwinkel, *Dr. Bessie*, 130–35; *Wausau Daily Herald*, October 18, 1979.

57. Rehwinkel, *Dr. Bessie*, 130–35.

58. Missouri Division of Health-Standard, certificate of death, Bessie Rehwinkel, #62–021471.

59. *Statesman Journal*, February 20, 1920.

BETHENIA OWENS-ADAIR

1. Bethenia Angelina Owens-Adair, *Dr. Owens-Adair: Some of Her Life Experiences* (Whitefish, MT: Kessinger Publishing, 1906), 83–85.

2. Ibid.

3. Ibid.

4. Ibid.

5. Ibid.

6. Ibid.

7. Ibid.

8. Ibid.

9. Ibid.

10. Ibid.

11. Ibid.

12. Owens-Adair, *Dr. Owens-Adair*, 5–6.

13. Owens-Adair, *Dr. Owens-Adair*, 50–57.

14. Ibid.

15. Owens-Adair, *Dr. Owens-Adair*, 56–59.

16. Ibid.

17. Owens-Adair, *Dr. Owens-Adair*, 59–60.

18. Owens-Adair, *Dr. Owens-Adair*, 79–81.

19. Ibid.

20. Ibid.

21. Ibid.

22. Ibid.

23. Owens-Adair, *Dr. Owens-Adair*, 85–87.

24. Owens-Adair, *Dr. Owens-Adair*, 91–93.

25. Ibid.

26. Owens-Adair, *Dr. Owens-Adair*, 110.

27. Owens-Adair, *Dr. Owens-Adair*, 94–96.

28. Owens-Adair, *Dr. Owens-Adair*, 101–4.

29. Ibid.

30. Owens-Adair, *Dr. Owens-Adair*, 111–12.

31. Ibid.

32. Owens-Adair, *Dr. Owens-Adair*, 114.

33. Bethenia Angelina Owens-Adair, *A Pioneer Woman Doctor's Life*, Big Byte Books, 2016.

34. Owens-Adair, *A Pioneer Woman Doctor's Life*, 470.

35. https://www.oregonencyclopedia.org/articles/bethenia_owens_adair_1840_1926/.

36. *The Capital Journal*, September 13, 1926; *The Eugene Guard*, September 29, 1926.

37. "Human Sterilization: Dr. B. Owens Adair, Author of the Famous 'Human Sterilization Bill,'" circa 1910, Oregon State Library Collections, Call Number 362.36 A19.

LUCY HOBBS

1. Louise Cheney, "Lucy Hobbs Taylor—Chronicle of Beauty and Brains," *Golden West* 10, no. 3 (February 1974); *Cincinnati Daily Press*, September 19, 1860.

2. Cheney, "Lucy Hobbs Taylor."

3. Ibid.

4. Ibid.

5. Ibid.; Ralph W. Edwards, "The First Woman Dentist Lucy Hobbs Taylor, D.D.S.," *Bulletin of the History of Medicine* 25, no. 3 (May–June 1951): 277–83.

6. Chris Enss, *The Doctor Wore Petticoats: Women Physicians of the Old West* (Guilford, CT: TwoDot Books, 2006), xii–xiii.

7. Ibid.

8. Ibid.

9. Cheney, "Lucy Hobbs Taylor"; Edwards, "The First Woman Dentist."

10. Cheney, "Lucy Hobbs Taylor"; Edwards, "The First Woman Dentist."

11. Cheney, "Lucy Hobbs Taylor"; Edwards, "The First Woman Dentist."

12. Cheney, "Lucy Hobbs Taylor"; Edwards, "The First Woman Dentist"; https://www.encyclopedia.com/women/encyclopedias-almanacs-transcripts-and-maps/taylor-lucy-hobbs-1833-1910.

13. Cheney, "Lucy Hobbs Taylor"; Edwards, "The First Woman Dentist"; https://www.encyclopedia.com/women/encyclopedias-almanacs-transcripts-and-maps/taylor-lucy-hobbs-1833-1910.

14. Cheney, "Lucy Hobbs Taylor"; Edwards, "The First Woman Dentist"; https://www.encyclopedia.com/women/encyclopedias-almanacs-transcripts-and-maps/taylor-lucy-hobbs-1833-1910.

15. Cheney, "Lucy Hobbs Taylor"; Edwards, "The First Woman Dentist"; https://www.encyclopedia.com/women/encyclopedias-almanacs-transcripts-and-maps/taylor-lucy-hobbs-1833-1910.

16. Cheney, "Lucy Hobbs Taylor"; Edwards, "The First Woman Dentist"; https://www.encyclopedia.com/women/encyclopedias-almanacs-transcripts-and-maps/taylor-lucy-hobbs-1833-1910.

17. Cheney, "Lucy Hobbs Taylor"; Edwards, "The First Woman Dentist"; https://www.encyclopedia.com/women/encyclopedias-almanacs-transcripts-and-maps/taylor-lucy-hobbs-1833-1910.

18. Edwards, "The First Woman Dentist."

19. Ibid.; *The Morning Democrat*, July 24, 1865.

20. Cheney, "Lucy Hobbs Taylor"; Edwards, "The First Woman Dentist"; https://www.encyclopedia.com/women/encyclopedias-almanacs-transcripts-and-maps/taylor-lucy-hobbs-1833-1910.

21. Cheney, "Lucy Hobbs Taylor"; Edwards, "The First Woman Dentist"; https://www.encyclopedia.com/women/encyclopedias-almanacs-transcripts-and-maps/taylor-lucy-hobbs-1833-1910.

22. Cheney, "Lucy Hobbs Taylor"; Edwards, "The First Woman Dentist"; https://www.encyclopedia.com/women/encyclopedias-almanacs-transcripts-and-maps/taylor-lucy-hobbs-1833-1910.

23. *Charles City Intelligencer*, March 29, 1866.

24. Pennsylvania College of Dental Surgery, *The Dental Times, 1866*, vol. 3 (Philadelphia, Pennsylvania, 1866).

25. Ibid.; *Vermont Record*, December 22, 1866.

26. Cheney, "Lucy Hobbs Taylor"; Edwards, "The First Woman Dentist"; https://www.encyclopedia.com/women/encyclopedias-almanacs-transcripts-and-maps/taylor-lucy-hobbs-1833-1910.

27. *The Lawrence Tribune*, April 26, 1882.

28. Cheney, "Lucy Hobbs Taylor"; Edwards, "The First Woman Dentist"; https://www.encyclopedia.com/women/encyclopedias-almanacs-transcripts-and-maps/taylor-lucy-hobbs-1833-1910.

29. *The Jeffersonian Gazette*, August 17, 1910; *La Cygne Weekly*, October 13, 1910.

30. https://www.hmdb.org/m.asp?m=88888/Lucy Hobbs Taylor.

31. Edwards, "The First Woman Dentist."

32. W. W. H. Thackston, MD, DDS, "The File, as a Dental Instrument," *American Journal of Dental Science*, May 1, 1867.

FANNIE DUNN QUAIN

1. Department of Commerce and Labor, Bureau of Census, *Mortality Statistics 1906, Seventh Annual Report* (Washington, DC: Government Printing Office, 1908).

2. https://cfmedicine.nlm.nih.gov/Fannie Dunn Quain.

3. *The Bismarck Tribune*, February 2, 1950.

4. Ibid.

5. Ibid.

6. Ibid.

7. Ibid.

8. Ibid.

9. Ibid.

10. Letter from Department of Interior Bismarck, North Dakota, September 24, 1894.

11. *The Bismarck Tribune*, February 2, 1950.

12. *The Bismarck Tribune*, February 2, 1950; https://www.facebook.com/84598793508/photos/10158125813918509/Katherine Crawford.

13. *The Bismarck Tribune*, February 2, 1950.

14. *The Bismarck Tribune*, July 11, 1899.

15. *The Bismarck Tribune*, August 8, 1900; *The Bismarck Tribune*, August 10, 1900; *Bismarck Weekly Tribune*, November 16, 1900.

16. *The Bismarck Tribune*, March 1, 2009; *Williston Herald*, January 20, 1961.

17. *The Bismarck Tribune*, March 1, 2009.

18. *The Bismarck Tribune*, November 22, 1900.

19. *The Bismarck Tribune*, March 26, 1903.

20. Ibid.

21. *The Wahpeton Times*, May 13, 1904.

22. *The State-Line Herald*, May 15, 1908.

23. *The Bismarck Tribune*, February 26, 1909.

24. Ibid.

25. https://www.history.nd.gov/archives/stateagencies/sanhaven.html.

26. *The Bismarck Tribune*, January 12, 1928; https://www.jstor.org/stable/25384947; An Address on Tuberculosis R. W. Phillip.

27. *The Bismarck Tribune*, February 2, 1950; *The Bismarck Tribune*, January 12, 1928.

28. https://cfmedicine.nlm.nih.gov/Fannie Dunn Quain.

29. *The Bismarck Tribune*, February 2, 1950; *The Bismarck Tribune*, February 4, 1950.

30. "The Tuberculosis Treatment," *Public Health Report*, vol. 41, no. 5 (August 2, 1921).

HARRIET BELCHER

1. *Noticias Santa Barbara Historical Society Pamphlet*, vol. XXV, no. 2 (Spring 1979): 22–23.

2. Ibid.

3. Ibid.

4. Ibid.

5. *Noticias Santa Barbara Historical Society*, vol. XXV, no. 2: 17–19.

6. Ibid.; https://www.ancestry.com/1850 U.S. Federal Census for Harriet Gilliland Belcher; Ruth J. Abram, *Send Us a Lady Physician: Women Doctors in America, 1835–1920* (New York: W. W. Norton & Company, 1985), 57.

7. *Noticias Santa Barbara Historical Society* 25, no. 2: 18.

8. Ibid.

9. Abram, *Send Us a Lady Physician*, 92.

10. Ibid.

11. *Noticias Santa Barbara Historical Society*, vol. XXV, no. 2: 19–20.

12. *Noticias Santa Barbara Historical Society*, vol. XXV, no. 2: 159–60.

13. Ibid.

14. *Noticias Santa Barbara Historical Society*, vol. XXV, no. 2: 21–22.

15. *The Independent*, February 15, 1882.

16. Ibid.; *Noticias Santa Barbara Historical Society Pamphlet*, vol. XXV, no. 3 (Fall 1979): 38–39.

17. *Noticias Santa Barbara Historical Society*, vol. XXV, no. 3: 38–39.

18. *Noticias Santa Barbara Historical Society*, vol. XXV, no. 3: 40–41.

19. *Noticias Santa Barbara Historical Society*, vol. XXV, no. 3: 43.

20. *Noticias Santa Barbara Historical Society*, vol. XXV, no. 2: 23.

21. *Noticias Santa Barbara Historical Society*, vol. XXV, no. 2: 24.

22. *Noticias Santa Barbara Historical Society*, vol. XXV, no. 2: 24–25.

23. *Noticias Santa Barbara Historical Society*, vol. XXV, no. 2: 25–26.

24. Ibid.

25. Ibid.

26. *Noticias Santa Barbara Historical Society*, vol. XXV, no. 2: 27; *Noticias Santa Barbara Historical Society*, vol. XXV, no. 3: 47.

27. Ibid.

28. *The Morning Press*, May 31, 1887; www.ancestry.com/Death/Discovery, Harriet Gilliland Belcher.

29. *Douglas Island News*, Douglas, Alaska, November 4, 1918.

ROMANIA PRATT

1. https://www.jared.pratt-family.org/parley_family_histories/romania-bunnell-brave -world.html.

2. Ibid.; Emeline Wells, "The Woman's Exponent 1880-04-15," *Nineteenth Century Mormon Publications* 8, no. 22 (April 15, 1880).

3. https://www.jared.pratt-family.org/parley_family_histories/romania-bunnell-brave -world.html.

4. Ibid.; Colleen Whitley and Shana Montgomery, *Worth Their Salt Too: More Notable but Often Unnoted Women of Utah* (Logan, UT: Utah State University Press, 2000), 32.

5. https://www.jared.pratt-family.org/parley_family_histories/romania-bunnell-brave -world.html; Whitley and Montgomery, *Worth Their Salt Too*, 30–31.

6. https://www.jared.pratt-family.org/parley_family_histories/romania-bunnell-brave -world.html; Whitley and Montgomery, *Worth Their Salt Too*, 30–31.

7. https://www.jared.pratt-family.org/parley_family_histories/romania-bunnell-brave -world.html; Whitley and Montgomery, *Worth Their Salt Too*, 31–32.

8. https://www.jared.pratt-family.org/parley_family_histories/romania-bunnell-brave -world.html; Whitley and Montgomery, *Worth Their Salt Too*, 32–33; https://www.history. churchofjesuschrist.org/chd/individual/parley-parker-pratt-jr-1837?lang=eng.

9. https://www.jared.pratt-family.org/parley_family_histories/romania-bunnell-brave -world.html; Whitley and Montgomery, *Worth Their Salt Too*, 31–33.

10. https://www.jared.pratt-family.org/parley_family_histories/romania-bunnell-brave -world.html; Whitley and Montgomery, *Worth Their Salt Too*, 34.

11. https://www.jared.pratt-family.org/parley_family_histories/romania-bunnell-brave -world.html.

12. Ibid.; Whitley and Montgomery, *Worth Their Salt Too*, 34.

13. https://www.jared.pratt-family.org/parley_family_histories/romania-bunnell-brave -world.html; Whitley and Montgomery, *Worth Their Salt Too*, 34.

14. https://www.jared.pratt-family.org/parley_family_histories/romania-bunnell-brave -world.html; Whitley and Montgomery, *Worth Their Salt Too*, 34.

15. https://www.jared.pratt-family.org/parley_family_histories/romania-bunnell-brave -world.html; Whitley and Montgomery, *Worth Their Salt Too*, 34–35.

16. https://www.jared.pratt-family.org/parley_family_histories/romania-bunnell-brave -world.html.

17. Ibid.; Whitley and Montgomery, *Worth Their Salt Too*, 35.

18. *The Deseret News*, April 3, 1878.

19. *The Deseret News*, June 30, 1881.

20. Whitley and Montgomery, *Worth Their Salt Too*, 36.

21. Wells, "The Woman's Exponent 1880-04-15."

22. https://www.jared.pratt-family.org/parley_family_histories/romania-bunnell-brave -world.html; Whitley and Montgomery, *Worth Their Salt Too*, 37.

23. *The Allentown Democrat*, September 13, 1882; *Buffalo Morning Express*, January 13, 1882.

24. *The Ogden Standard*, December 16, 1882; *The Deseret News*, July 17, 1882.

25. https://www.jared.pratt-family.org/parley_family_histories/romania-bunnell-brave -world.html; Whitley and Montgomery, *Worth Their Salt Too*, 37–38.

26. https://www.jared.pratt-family.org/parley_family_histories/romania-bunnell-brave -world.html; Whitley and Montgomery, *Worth Their Salt Too*, 38–39.

27. https://www.jared.pratt-family.org/parley_family_histories/romania-bunnell-brave -world.html; Whitley and Montgomery, *Worth Their Salt Too*, 39; *The Salt Lake Tribune*, November 10, 1932.

28. https://www.merriam-webster.com/dictionary/hygiene

29. Romania Pratt, "Hygiene," *The Young Woman's Journal* 1, no. 1 (October 1889).

SOFIE HERZOG

1. Rachel Penland, "Eclectic Houstonians," *Houston History Magazine* 13, no. 3 (Summer 2016): 39–41; https://www.tshaonline.org/handbook/entries/herzog-sofie-dalia;https:// www.brazoriahf.org/site/museum/dr-sofie-herzog/; *The Facts*, February 19, 1999.

2. Penland, "Eclectic Houstonians," 39–41; https://www.tshaonline.org/handbook/entries/herzog-sofie-dalia; https://www.brazoriahf.org/site/museum/dr-sofie-herzog; *The Facts*, February 19, 1999.

3. https://www.ancestry.com, Texas U.S. Death Certificate for Sofie Herzog.

4. Penland, "Eclectic Houstonians," 39–41; https://www.tshaonline.org/handbook/entries/herzog-sofie-dalia; https://www.brazoriahf.org/site/museum/dr-sofie-herzog/; *The Facts*, February 19, 1999.

5. Penland, "Eclectic Houstonians," 39–41; https://www.tshaonline.org/handbook/entries/herzog-sofie-dalia; https://www.brazoriahf.org/site/museum/dr-sofie-herzog/; *The Facts*, February 19, 1999.

6. *New York Times*, May 5, 1895.

7. Penland, "Eclectic Houstonians," 39–41; https://www.tshaonline.org/handbook/entries/herzog-sofie-dalia; https://www.brazoriahf.org/site/museum/dr-sofie-herzog/; *The Facts*, February 19, 1999.

8. Penland, "Eclectic Houstonians," 39–41; https://www.tshaonline.org/handbook/entries/herzog-sofie-dalia; https://www.brazoriahf.org/site/museum/dr-sofie-herzog/; *The Facts*, February 19, 1999.

9. *Fort Worth Record and Register*, June 23, 1904.

10. Penland, "Eclectic Houstonians," 39–41; https://www.tshaonline.org/handbook/entries/herzog-sofie-dalia; https://www.brazoriahf.org/site/museum/dr-sofie-herzog/; *The Facts*, February 19, 1999.

11. *El Paso Herald*, January 4, 1910.

12. Penland, "Eclectic Houstonians," 39–41; https://www.tshaonline.org/handbook/entries/herzog-sofie-dalia; https://www.brazoriahf.org/site/museum/dr-sofie-herzog/; *The Facts*, February 19, 1999.

13. Penland, "Eclectic Houstonians," 39–41; https://www.tshaonline.org/handbook/entries/herzog-sofie-dalia; https://www.brazoriahf.org/site/museum/dr-sofie-herzog/; *The Facts*, February 19, 1999.

14. Penland, "Eclectic Houstonians," 39–41; https://www.tshaonline.org/handbook/entries/herzog-sofie-dalia; https://www.brazoriahf.org/site/museum/dr-sofie-herzog/; *The Facts*, February 19, 1999.

15. *The Houston Post*, June 4, 1908.

16. Penland, "Eclectic Houstonians," 39–41; https://www.tshaonline.org/handbook/entries/herzog-sofie-dalia; https://www.brazoriahf.org/site/museum/dr-sofie-herzog/; *The Facts*, February 19, 1999.

17. Penland, "Eclectic Houstonians," 39–41; https://www.tshaonline.org/handbook/entries/herzog-sofie-dalia; https://www.brazoriahf.org/site/museum/dr-sofie-herzog/; *The Facts*, February 19, 1999.

18. Penland, "Eclectic Houstonians," 39–41; https://www.tshaonline.org/handbook/entries/herzog-sofie-dalia; https://www.brazoriahf.org/site/museum/dr-sofie-herzog/; *The Facts*, February 19, 1999.

19. Sofie Herzog, MD, "Gunshot Wounds," 1903.

HELEN MACKNIGHT DOYLE

1. Helen M. Doyle, *Doctor Nellie: The Autobiography of Dr. Helen Macknight Doyle* (Mammoth Lakes, CA: Genny Smith Books, 1983), 248–49.

2. Ibid.

3. Ibid.

4. Ibid.

5. Ibid.

6. Ibid.

7. Doyle, *Doctor Nellie*, 15–18.

8. Doyle, *Doctor Nellie*, 39–41.

9. Doyle, *Doctor Nellie*, 46–47.

10. Ibid.

11. Doyle, *Doctor Nellie*, 52–54.

12. Doyle, *Doctor Nellie*, 62–64.

13. Ibid.

14. Doyle, *Doctor Nellie*, 63–65.

15. Doyle, *Doctor Nellie*, 81–82.

16. Doyle, *Doctor Nellie*, 83–84.

17. Doyle, *Doctor Nellie*, 139–41.

18. Ibid.

19. Ibid.

20. Doyle, *Doctor Nellie*, 148–49.

21. Doyle, *Doctor Nellie*, 154–56.

22. Doyle, *Doctor Nellie*, 215–18.

23. Ibid.

24. Doyle, *Doctor Nellie*, 233–35.

25. Ibid.

26. Doyle, *Doctor Nellie*, 240–42.

27. Doyle, *Doctor Nellie*, 254–55.

28. Doyle, *Doctor Nellie*, 277–78.

29. Doyle, *Doctor Nellie*, 291–93.

30. Ibid.

31. Doyle, *Doctor Nellie*, 285–87.

32. Ibid.

33. Ibid.

34. Ibid.

35. Doyle, *Doctor Nellie*, 287–88.

36. *The Pacific Medical Journal*, January–December 1895, vol. XXXVIII.

37. Ibid.

38. *Pacific Medical Journal* XXXVIII (January–December 1895).

39. Doyle, *Doctor Nellie*, 299–301.

40. Ibid.

41. Doyle, *Doctor Nellie*, 320–21.

42. Doyle, *Doctor Nellie*, 322–23.

43. Doyle, *Doctor Nellie*, 324–26.
44. Ibid.
45. Ibid.
46. Doyle, *Doctor Nellie*, 288.
47. Doyle, *Doctor Nellie*, 329–30.
48. San Francisco Area Funeral Home, Dr. Helen M. MacKnight, death certificate, records book no. 57, 469.
49. W. M. Jenner, "An Address on the Treatment of Typhoid Fever," *The Lancet Medical Journal* 114, no. 2933 (November 1879): 715–20, https://doi.org/10.1016/S0140-6736(02)47448-X.

ELIZABETH MCDONALD WATSON

1. *The Union*, April 2, 1951; *The Union*, April 6, 1952; *The Union*, July 3, 2008.
2. *The Union*, April 2, 1951; *The Union*, April 6, 1952; *The Union*, July 3, 2008.
3. https://www.ancestry.com/Elizabeth McDonald Watson; *The Union*, April 2, 1951; *The Union*, April 6, 1952; *The Union*, July 3, 2008.
4. *The Union*, April 2, 1951; *The Union*, April 6, 1952; *The Union*, July 3, 2008.
5. *The Union*, April 2, 1951; *The Union*, April 6, 1952; *The Union*, July 3, 2008.
6. *The Union*, April 2, 1951; *The Union*, April 6, 1952; *The Union*, July 3, 2008.
7. *The Union*, April 2, 1951; *The Union*, April 6, 1952; *The Union*, July 3, 2008.
8. *The Union*, April 2, 1951; *The Union*, April 6, 1952; *The Union*, July 3, 2008.
9. *The Union*, April 2, 1951; *The Union*, April 6, 1952; *The Union*, July 3, 2008.
10. *The Union*, April 2, 1951; *The Union*, April 6, 1952; *The Union*, July 3, 2008.
11. *The Union*, April 2, 1951; *The Union*, April 6, 1952; *The Union*, July 3, 2008.
12. *The Union*, April 6, 1951.
13. *The Union*, April 2, 1951; *The Union*, April 6, 1952; *The Union*, July 3, 2008.
14. *The Union*, January 5, 1957.
15. Nurse Watson's Medical Recipes, taken from her handwritten medical records.

BIBLIOGRAPHY

BOOKS

Abram, Ruth J. *Send Us a Lady Physician: Women Doctors in America 1835–1920*. New York: W. W. Norton & Company, 1985.

Anadiotis, K. A. *Great Lives in Colorado History: Justina Ford: Baby Doctor*. Palmer Lake, CO: Filter Press, 2013.

Brooks, Juanita. *Emma Lee*. Logan, UT: Utah State University Press, 1978.

Burgess, Vicky D. *Ellis Shipp: Sister Saints*. Provo, UT: Brigham Young University Press, 1978.

Doyle, Helen M. *Doctor Nellie: The Autobiography of Dr. Helen Macknight Doyle*. Mammoth Lakes, CA: Genny Smith Books, 1983.

Enss, Chris. *The Doctor Wore Petticoats: Women Physicians of the Old West*. Guilford, CT: TwoDot Books, 2006.

Gunn, John C. *Gunn's Domestic Medicine: Or Poor Man's Friend, Shewing the Diseases of Men, Women, and Children Expressly Intended for the Benefit of Families*. Knoxville, TN: University of Tennessee Press, 1830.

Karolevitz, Robert F. *Doctors of the Old West: A Pictorial History of Medicine on the Frontier*. New York: Bonanza Books, 1967.

Luchetti, Cathy. *Medicine Women: The Story of Early-American Women Doctors*. New York: Crown Publishers, 1998.

Owens-Adair, Bethenia Angelina. *A Pioneer Woman Doctor's Life*. Big Byte Books, 2016.

———. *Dr. Owens-Adair: Some of Her Life Experiences*. Whitefish, MT: Kessinger Publishing, 1906.

Rehwinkel, Alfred M. *Dr. Bessie: The Life Story and Romance of a Pioneer Lady Doctor on Our Western and the Canadian Frontier*. St. Louis, MO: Concordia Publishing House, 1963.

Seagraves, Anne. *Women of the Sierra*. Hayden, ID: Wesanne Publications, 1990.

Whitley, Colleen, and Shana Montgomery. *Worth Their Salt Too: More Notable but Often Unnoted Women of Utah*. Logan, UT: Utah State University Press, 2000.

NEWSPAPERS

The Allen County Republican Gazette, Lima, OH, October 1, 1895.

The Allentown Democrat, Allentown, PA, September 13, 1882.

Argus Leader, Sioux Falls, SD, October 21, 1951.

Arizona Daily Star, Tucson, AZ, August 8, 1880.

Arizona Daily Star, Tucson, AZ, August 20, 1880.

Arizona Daily Star, Tucson, AZ, June 24, 1923.

Arizona Republic, Phoenix, AZ, September 11, 1891.

The Austin American, Austin, TX, July 21, 1952.

The Bismarck Tribune, Bismarck, ND, August 8, 1900.

The Bismarck Tribune, Bismarck, ND, August 10, 1900.

The Bismarck Tribune, Bismarck, ND, February 26, 1909.

The Bismarck Tribune, Bismarck, ND, February 2, 1950.

The Bismarck Tribune, Bismarck, ND, February 4, 1950.

The Bismarck Tribune, Bismarck, ND, July 11, 1899.

The Bismarck Tribune, Bismarck, ND, January 12, 1928.

The Bismarck Tribune, Bismarck, ND, March 26, 1903.

The Bismarck Tribune, Bismarck, ND, March 1, 2009.

The Bismarck Tribune, Bismarck, ND, November 22, 1900.

Bismarck Weekly Tribune, Bismarck, ND, November 16, 1900.

The Brazosport Facts, Freeport, TX, February 8, 1961.

Buffalo Morning Express, Buffalo, NY, January 13, 1882.

The Capital Journal, Salem, OR, September 13, 1926.

Casper Morning Star, Casper, WY, December 30, 1960.

Casper Star-Tribune, Casper, WY, August 6, 1962.

Casper Star-Tribune, Casper, WY, April 2, 1995.

Charles City Intelligencer, Charles City, IA, March 29, 1866.

Cincinnati Daily Press, Cincinnati, OH, September 19, 1860.

The Daily Journal of Commerce, Kansas City, MO, March 7, 1877.

The Daily Sentinel, Grand Junction, CO, August 30, 1955.

The Denver Star, Denver, CO, August 12, 1915.

The Deseret Evening News, Salt Lake City, UT, September 27, 1875.

The Deseret News, Salt Lake City, UT, November 11, 1874.

The Deseret News, Salt Lake City, UT, November 18, 1874.

The Deseret News, Salt Lake City, UT, April 3, 1878.

The Deseret News, Salt Lake City, UT, June 30, 1881.

The Deseret News, Salt Lake City, UT, July 17, 1882.

El Paso Herald, El Paso, TX, January 4, 1910.

The Eugene Guard, Eugene, OR, September 29, 1926.

The Facts, Clute, TX, February 19, 1999.

Fayetteville Semi-Weekly Observer, Fayetteville, NC, February 16, 1857.

Fort Worth Record and Register, Fort Worth, TX, June 23, 1904.

The Gaffney Ledger, Gaffney, SC, September 25, 1923.

Green-Mountain Freeman, Montpelier, VT, March 28, 1877.

The Houston Post, Houston, TX, June 4, 1908.

The Independent, Wakefield, RI, February 15, 1882.

The Independent Record, Helena, MT, August 11, 1918.
Jamestown Weekly Alert, Jamestown, ND, July 13, 1899.
The Jeffersonian Gazette, Lawrence, KS, August 17, 1910.
La Cygne Weekly, La Cygne, KS, October 13, 1910.
The Lawrence Tribune, Lawrence, KS, April 26, 1882.
The Monmouth Inquirer, Freehold, NJ, April 21, 1910.
The Morning Democrat, Davenport, IA, July 24, 1865.
The Morning Press, Santa Barbara, CA, May 31, 1887.
Nevada Evening Gazette, Reno, NV, March 3, 1973.
Nevada State Journal, Reno, NV, June 9, 1946.
New York Times, New York, NY, May 5, 1895.
The News, Frederick, MD, May 13, 1950.
The Observer, London, Greater London, England, October 14, 1895.
The Ogden Standard, Ogden, UT, December 16, 1882.
Pittsburgh Sun-Telegraph, Pittsburgh, PA, July 21, 1940.
Rapid City Journal, Rapid City, SD, January 13, 2013.
Reno Gazette Journal, Reno, NV, May 5, 1892.
Reno Gazette Journal, Reno, NV, October 3, 1947.
Reno Gazette Journal, Reno, NV, March 27, 2008.
St. Johns Herald, St. Johns, AZ, November 27, 1897.
The Salt Lake Herald, Salt Lake City, UT, April 10, 1879.
The Salt Lake Tribune, Salt Lake City, UT, November 10, 1932.
Sioux City Journal, Sioux City, IA, June 25, 1903.
The Southern Standard, Arkadelphia, AR, March 8, 1879.
The State-Line Herald, North Lemmon, ND, May 15, 1908.
The Tooele Bulletin, Tooele, UT, July 17, 1962.
The Union, Grass Valley, CA, April 2, 1951.
The Union, Grass Valley, CA, April 6, 1951.
The Union, Grass Valley, CA, January 5, 1957.
The Union, Grass Valley, CA, July 3, 2008.
Vermont Record, Brandon, VT, December 22, 1866.
The Wahpeton Times, Wahpeton, ND, May 13, 1904.
Wausau Daily Herald, Wausau, WI, October 18, 1979.
Williston Herald, Williston, ND, January 20, 1961.

ARCHIVES, NEWSLETTERS, MAGAZINES

Cheney, Louise. "Lucy Hobbs Taylor—Chronicle of Beauty and Brains." *Golden West* 10, no. 3 (February 1974).
Department of Commerce and Labor, Bureau of Census. *Mortality Statistics 1906, Seventh Annual Report*. Washington, DC: Government Printing Office, 1908.
"Doctors of the Old West." *Journey of Midwifery & Women's Health* 54 (September 2009): 13–19.
Dr. Jenny Murphy F453. Yankton County Historical Society, Pierre, SD. Historical records.

Edwards, Ralph W. "The First Woman Dentist Lucy Hobbs Taylor, D.D.S.," *Bulletin of the History of Medicine* 25, no. 3 (May–June 1951): 277–83.

Heath, Lillian. Oral history interview by Helen Hubert. American Heritage Center, University of Wyoming, January 6, 196.

"Human Sterilization: Dr. B. Owens Adair, Author of the Famous 'Human Sterilization Bill.'" Circa 1910, Oregon State Library Collections, Call Number 362.36 A19.

Jenner, W. M. "An Address on the Treatment of Typhoid Fever." *The Lancet Medical Journal* 114, no. 2933 (November 1879): 715–20. https://doi.org/10.1016 / S0140-6736(02)47448-X.

Kildare, Maurice. "Doctor Grandma French." *Frontier Times* 41, no. 4 (July 1967): 14–17.

Letter from Department of Interior, Bismarck, North Dakota, September 24, 1894.

Letter from State of North Dakota Department of Public Instruction, John G. Halland, Superintendent, to Fannie Dunn.

Maghee, Thomas. "The Case of Reconstructive Surgery of the Face." *Colorado Medicine Journal*, 17–18 (March 1920).

Missouri Division of Health-Standard, certificate of death, Bessie Rehwinkel, #62–021471.

Noticias Santa Barbara Historical Society Pamphlet, vol. XXV, no. 2, Spring 1979.

Noticias Santa Barbara Historical Society Pamphlet, vol. XXV, no. 3, Fall 1979.

Pacific Medical Journal XXXVIII (January–December 1895).

Parker, Caroline. "Optical Sanitation." *The Indian Medical Gazette* 15, no. 32 (May 27, 1891).

Penland, Rachel. "Eclectic Houstonians." *Houston History Magazine* 13, no. 3 (Summer 2016): 39–41.

Pennsylvania College of Dental Surgery. *The Dental Times, 1866.* Vol. 3. Philadelphia, Pennsylvania, 1866.

Physicians & Medicine in Early Lowell, Doctors of the Old West. University of Massachusetts Library, Amherst, MA. Historical records, hanging file.

Pratt, Romania. "Hygiene." *The Young Woman's Journal* 1, no. 1 (October 1889).

San Francisco Area Funeral Home, Dr. Helen M. Macknight, death certificate, records book no. 57, 469.

Wells, Emeline. "The Woman's Exponent 1880-04-15." *Nineteenth Century Mormon Publications* 8, no. 22 (April 15, 1880).

WEBSITES

https://www.ancestry.com/Dr. Bess Lee Rehwinkel.

https://www.ancestry.com/Elizabeth McDonald Watson.

https://www.ancestry.com/1850 U.S. Federal Census for Harriet Gilliland Belcher.

https://www.ancestry.com/Death/Discovery, Harriet Gilliland Belcher.

https://www.ancestry.com/Death/Discovery, Texas U.S. Death Certificate for Sofie Herzog.

https://www.ancestry.com/FannieDunnQuain/Death Certificate.

https://www.ancestry.com/Maria M. Dean.

https://www.ancestry.com/Nevada Death Certificates, 1911–1965 for Eliza Cook.

https://www.ancestry.com/search/collections/6742/United State Federal Census.

https://www.brazoriahf.org/site/museum/dr-sofie-herzog/.

https://www.cambridge.org/core/journals/medical-history/article/epidemiology-of -puerperal-fever-the-contributions-of-alexander-gordon/C917A91D221BD13C EF6724018B316353.

https://www.cfmedicine.nlm.nih.gov/Fannie Dunn Quain.https://www.cfmedicine.nlm .nih.gov/physicians/biography_351.html Fannie Dunn Quain.

https://www.churchhistorianpress.org/emmeline-b-wells/people/romania-bunnell-1839 ?letter=B&lang=tam#_ftnref1.

https://www.digging-history.com/2015/06/12/feisty-females-dr-lillian-heath.

https://www.encyclopedia.com/women/encyclopedias-almanacs-transcripts-and-maps/ taylor-lucy-hobbs-1833-1910.

https://www.facebook.com/84598793508/photos/10158125813918509/Katherine Crawford.

https://www.geni.com/people/Dr.-Emma-French.

https://www.history.churchofjesuschrist.org/chd/individual/parley-parker-pratt-jr-1837 ?lang=eng.

https://www.history.nd.gov/archives/stateagencies/sanhaven.html.

https://www.hmdb.org/m.asp?m=88888/Lucy Hobbs Taylor.

https://www.jstor.org/stable/25384947.

https://www.jared.pratt-family.org/parley_family_histories/romania-bunnell-brave -world.html.

https://www.legendsofamerica.com/diseases-death-overland-trails.

https://www.mayoclinic.org/diseases-conditions/trachoma/symptoms-causes/syc -20378505.

https://www.oregonencyclopedia.org/articles/bethenia_owens_adair_1840_1926.

https://www.tshaonline.org/handbook/entries/herzog-sofie-dalia.

http://www.wyohistory.org/encyclopedia/lillian-heath.

INDEX

Page references for figures are *italicized*.

Adair, John, 61
American Heritage Center, 13
American Nurses Association, 52
Anderson, Ole, 82
anesthesiology, 13, 14, 17
Argus Leader (periodical), 1, 5, 6
Atlantic & Pacific Railroad, 31–32

Baltimore College of Dental
 Surgery, 70
Batchelder, Emma. *See*
 French, Emma
Battle of the Little Bighorn, 81
Belcher, Caroline, 93
Belcher, Charles, 93
Belcher, Harriet, 91–99, *92*; birth,
 93; death, 99; education, 93–95;
 medical career, 91, 93, 95–99
Belcher, Stephen, 99
Bellevue Women's Medical
 College, 106
Ben-Mar Hotel, 15
Bismarck Tribune (periodical), 79,
 84, 86, 87, 88

Blackwell, Elizabeth, 13, 22
black women doctors, x, 83
blizzards, 4
Boston Female Medical
 College, 24
Boston Hospital, 94
Boston University School of
 Medicine, ix
Bradbury Hotel, 141
Brooks, Juanita, 27
Buchannan, James, 3
Bunnell, Esther Mendenhall,
 105, 106
Bunnell, Luther B., 105

Callan, P. A., 107
Cannon, Angus J., 108
Cannon, George Q., 108
Cannon, Martha Hughes, viii
Charles City Intelligencer
 (periodical), 73–74
Chautauqua School, 144
Chicago, Burlington, and Quincy
 Railroad, 35
Church of Latter-Day Saints, viii,
 30, 103, 105, 107
Civil War, 71

About the Author

Chris Enss is a *New York Times* best-selling author who has been writing about women of the Old West for more than twenty years. She has penned more than forty published books on the subject. Her work has been honored with five Will Rogers Medallion Awards, an Elmer Kelton Book Award, an Oklahoma Center for the Book Award, three Foreword Review Magazine Book Awards, and two Western Writers of America Spur Finalist Awards. Enss's most recent works are *According to Kate: The Legendary Life of Big Nose Kate Elder, Love of Doc Holliday*; *No Place for a Woman: The Fight for Suffrage in the Wild West*; *Iron Women: The Ladies Who Helped Build the Railroad*; *The Lady and the Mountain Man: Isabella Bird, Mountain Man Jim Nugent, and their Unlikely Friendship*; *The Widowed Ones: Beyond the Battle of the Little Bighorn*; and *Along Came a Cowgirl: Daring and Iconic Cowgirls of Rodeos and Wild West Shows*.

Enss is also the executive director of the Will Rogers Medallion Award.